GV
863
.I32
L47
2000

TOMAN

Chicago Public Library
cago

D0862771

27th ST.
CHICAGO, ILLINOIS 60629

BLACK AMERICA SERIES

BLACK BASEBALL
IN CHICAGO

DISCARD

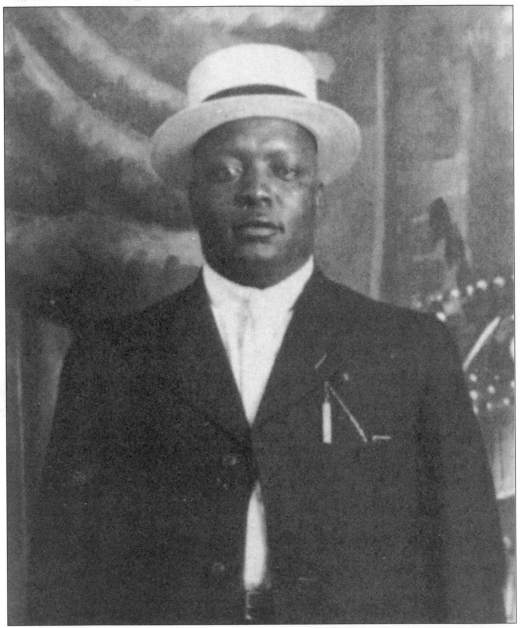

He was called the "Father of Black Baseball." On the eighth day, Andrew "Rube" Foster created the Negro National League of Colored Baseball Professionals, better known as the Negro National League. It was the first league of color to survive a full season. Foster became the genetic Eve of black baseball, birthing a confederacy of clubs to embrace a permanent existence of top quality baseball. The league's motto was "We Are the Ship, All Else the Sea." Going against the tide of segregation, Rube's voyage became an obsession. For many years, Captain Rube struggled without a life preserver in his attempts to keep the league afloat. He argued that their exclusion from the National Pastime was a symbolic rip in the American flag. His struggles became our successes, as black ball exploded in popularity and became an integral part of baseball Americana.

TOMAN BRANCH
4005 W. 27th ST.
CHICAGO, ILLINOIS 60623

BLACK AMERICA SERIES

BLACK BASEBALL IN CHICAGO

Larry Lester, Sammy J. Miller, and Dick Clark

ARCADIA

Copyright © 2000 by Larry Lester, Sammy J. Miller, and Dick Clark
ISBN 0-7385-0704-0

Published by Arcadia Publishing,
an imprint of Tempus Publishing, Inc.
3047 N. Lincoln Ave. Suite 410
Chicago, IL 60657

Printed in Great Britain.

Library of Congress Catalog Card Number: 00-101510

For all general information contact Arcadia Publishing at:
Telephone 773-549-7002
Fax 773-549-7190
E-Mail arcadia@charleston.net

For customer service and orders:
Toll-Free 1-888-313-BOOK

Visit us on the internet at http://www.arcadiaimages.com

CONTENTS

Acknowledgments 6

Introduction 7

1. The Early Years, 1884–1910 9
 Page Fence Giants
 Union Giants
 Leland Giants

2. The Foster Years, 1911–1930 31
 Chicago American Giants

3. A New Era for Chicago Baseball 55
 Cole's American Giants
 Hall's American Giants
 Martin's American Giants

4. Black Baseball's Signature Event 79
 The East-West All-Star Classic

5. The Great Lakes Naval Baseball Club 97

6. Major League Giants 103

7. The Recognition Years 115

8. The Last At Bat 123

ACKNOWLEDGMENTS

We would like to thank the following people for their personal commitment to this wonderful chapter in African-American history: Lisa Feder, Doris Foster, Joi Lester, Jerry Malloy, and Gene and Barbara Miller.

Dedication
This book is dedicated to the creative genius of Andrew "Rube" Foster, who suffered a breakdown trying to break through white baseball's color barrier.

INTRODUCTION

America's Black Giants

The saga of American Giants stomping through Chicagoland consists of various phases of triumph and disappointment, including some great teams and some mediocre teams, amid several ownerships.

Frank Leland, a native of Memphis, Tennessee, cultivated the seeds of black baseball. A Fisk University product, Leland began his baseball career with the Washington Capital Cities in the League of Colored Baseball Clubs. When the league folded in mid-season, Leland moved to Chicago and later, in 1901, founded the Union Giants. Three years later, he christened the team with his surname.

Around 1905, Andrew Foster, a brash, boastful son of a Methodist minister, was making a name for himself up East. As a pitcher for the Philadelphia Giants, he defeated Rube Waddell and the Philadelphia A's in a post-season exhibition game. Not only did Foster take the glory of defeating this future Hall of Famer, but he also took his name, Rube. Soon after, in 1907, Leland signed the young, brash pitcher from Calvert, Texas.

By 1909, Foster was managing the Leland Giants. After a split with Frank Leland in 1910, the Giants finished with 123 victories against six losses. The talented tan contingent boasted of such legendary stars as Bruce Petway, Pete Hill, Grant "Home Run" Johnson, and future Hall of Famer John Henry "Pop" Lloyd.

The following year, 1911, the Chicago American Giants were born. Foster had enticed the best players from the Leland Giants and other teams to form the nucleus of the strongest independent team in the Midwest. On any given Sunday afternoon, Rube's black brand of baseball often outdrew his cross-town rivals, the White Sox and the Cubs.

The American Giants were known for their flashy, up-tempo brand of baseball, with hit-and-run plays, double steals, and do-or-die sacrifice bunts. Foster's teams were also renowned for their pitching and superb defense. Their innovative style of play became the benchmark by which future black teams were measured. During the early teens, Foster's Giants often claimed the unofficial world colored championship.

As America entered World War I, Foster realized the drawbacks of independent baseball. He, like other black team owners, was at the mercy of white booking agents who scheduled games at the convenience of the resident white teams. Invariably, Foster realized that creating a stable league was the best approach for establishing continuity of scheduled games throughout black baseball.

In 1920, Foster met with other independent team owners at the Paseo YMCA in Kansas City, Missouri. The meeting of minds produced the Negro National League (NNL). Besides Foster's American Giants, charter members included Joe Green's Chicago Giants, John Matthews' Dayton (OH) Marcos, Tenny Blount's Detroit Stars, C.I. Taylor's Indianapolis ABCs, Lorenzo Cobb's St. Louis Giants, and J.L. Wilkinson's Kansas City Monarchs. Wilkinson was the only white owner in the league.

With Foster's ingenuity in moving players between teams for parity, producing a fixed schedule, and providing front money for financially meager teams, the NNL became the first black league to survive a full season. A strong influence, the league structure was cloned in 1923 with the birth of the Eastern Colored League, with teams based in the northeastern United States.

The American Giants won the league championship the first three years, before the Monarchs stopped their reign. After a two-year hiatus, the American Giants returned to the summit with league championships in 1926 and 1927. Both years they faced the

Bacharach Giants in the Colored World Series. Overcoming a no-hitter by Red Grier in the first series, they won the crown behind Rube's younger brother Willie's fine pitching performance. They repeated as world champions the following year.

Between series victories, the black baseball's kingpin, Rube Foster, was committed to a mental institution in Kankakee, Illinois. The American Giants were eventually sold to white businessman William E. Trimble, a florist.

Unable to withstand the devastation of the Great Depression, the American Giants folded with the league's collapse in 1931. Fittingly, they were reborn in 1932 under a new owner, mortician Robert A. Cole, as they won the Negro Southern League championship. The next year, 1933, Cole's American Giants joined the reorganized Negro National League. In their first season, Cole's colored Giants won the championship, only to have it vetoed by league president Gus Greenlee. Greenlee's team, The Pittsburgh Crawfords, was declared winner. In 1934, the American Giants lost the league playoffs, 4 to 3, to the Philadelphia Stars. Citing problems with President Greenlee, the American Giants resigned from league play after 1935.

In 1937, H.G. Hall became president of the American Giants and led the way in the creation of a Midwest-based league called the Negro American League. The revamped American Giants played from 1937 through the 1952 season. While maintaining their historically zenith quality of play, they were unable to capture another league title.

Despite the lack of championships in the closing years, the American Giants were not the only attraction emanating from the great black metropolis on Chicago's South Side. The grand apex of any Negro League season, without question, was the East-West All-Star game. It was the shadow ball version of the Major League baseball's mid-season classic. Starting in 1933, the signature event was played annually at Comiskey Park.

Outside of a Joe Louis fight, the star-studded affair became the most important black sporting event in America, attracting roughly 20,000 fans in its inaugural game (despite inclement weather). Eventually, attendance grew to over 50,000 in the early forties, outdrawing major league's own all-star contests. Many historians, players, and fans alike agree that the overall success of the East-West classics was the chief factor leading to the integration of major league baseball.

Frank Leland's Giants, Foster's original American Giants, and subsequent offsprings were truly gigantic in their accomplishments in giving our national pastime such a fine product of sporting achievement.

One
THE EARLY YEARS,
1884-1910

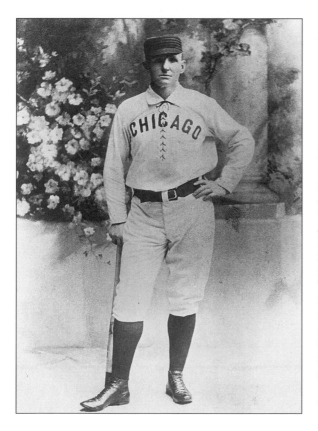

In 1884, the Chicago White Stockings were scheduled to play a game against Toledo, of the American Association. When Chicago's manager Adrian "Cap" Anson saw Toledo's catcher, Fleetwood Walker, Anson is reported to have yelled, "Get that nigger off the field!" Although Walker played that day, pressure from Anson resulted in the infamous "gentleman's agreement," the unwritten rule barring blacks from playing in the major leagues, which was in place at the start of the 1885 season. (Courtesy of National Baseball Hall of Fame.)

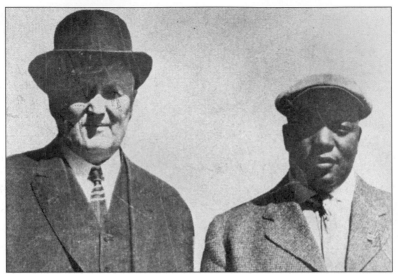

Truly the odd couple, pictured here are Cap Anson (left) and Rube Foster. Some historians believed that Anson, due to his immense popularity and stance against black players competing on the same field as whites, was responsible for segregating baseball. While Foster fought for the acceptance of black players into the white majors through traditional means, he also frequently sought to befriend his adversaries. (Courtesy of National Baseball Hall of Fame.)

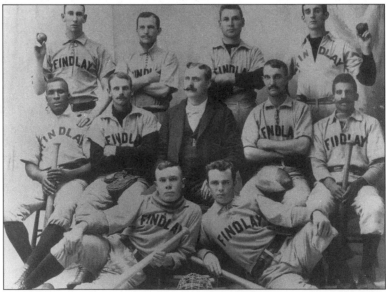

In 1878, Bud Fowler, whose real name was John W. Jackson, became the first black to play in the minor leagues. Until 1894, Fowler, originally a pitcher and later a second baseman, plied his trade in 13 different minor leagues. A year before organizing his own team, he played for the Findlay, Ohio team. Pictured from left to right are: (front row) F. Schwartz and Kid Odgen; (middle row) Grant "Home Run" Johnson, George Darby, Charles Strofel, Bobby Woods, and Bud Fowler; and (back row) Harvey Pastorius, Fred Cook, Howard Brandenberg, and Bill Reedy. (Courtesy of Hancock Historical Museum.)

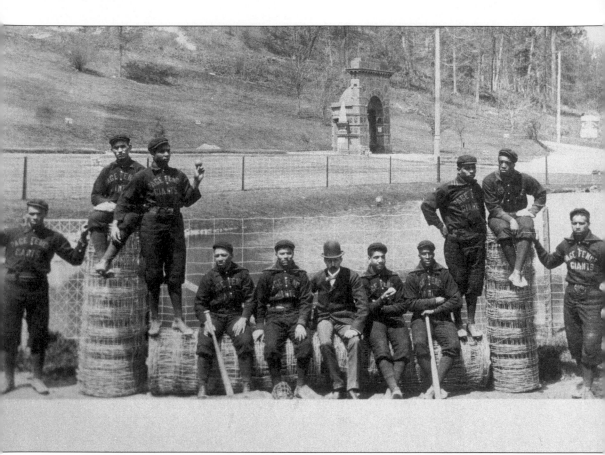

Formed by the Page Fence Company of Adrian, Michigan, in 1894, the Page Fence Giants would become one of the most dominant teams in baseball. The 1895 team finished the season with a record of 118 wins, 36 losses, and 2 ties. The 1895 Giants, from left to right, were: ? Walker, Charlie Grant, George Wilson, John W. Patterson, Pete Burns, Augustus W. Patterson, unidentified, Grant Johnson, unidentified, Billy Holland, and unidentified. (Courtesy of Richard Bak.)

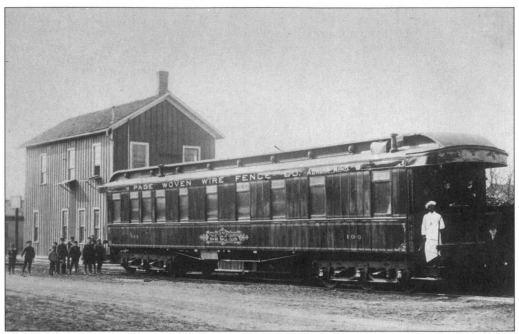

When this train car emblazoned with "Page Woven Wire Fence Co., Adrian, Michigan," rolled into a city, it brought a Cheshire smile to the faces of baseball fans everywhere. The Giants are here, the Giants are here! The team would parade to the ballpark or ride bicycles wearing fireman hats. Once the game started, the team continued to entertain the crowd with exhilarating feats of athleticism. (Courtesy of Jerry Malloy.)

The Page Fence Giants were organized on September 20, 1894, by J. Wallace Page as a public relations stratagem. The team played from 1894 to 1899, with the 1896 team, shown here in action, winning the "Colored Championship." After the team folded, most of the players joined the Chicago Columbia Giants in the middle of the 1899 season. (Courtesy of Jerry Malloy.)

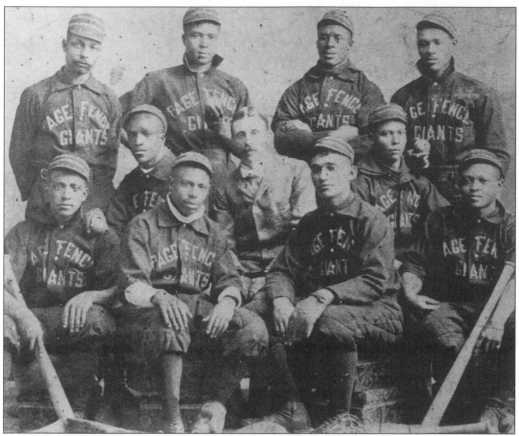

The 1896 Page Fence Giants put together a winning streak that managers dream about when the team won 32 straight games. The members of the 1896 team, from left to right, (front row) Fred Van Dyke, William Binga, Charlie Grant, Vasco Graham; (middle row) Billy Holland, manager Augustus "Gus" Parsons, Pete Burns; (back row) George Taylor, George Wilson, Grant "Home Run" Johnson, and ? Walker. (Courtesy of National Baseball Hall of Fame.)

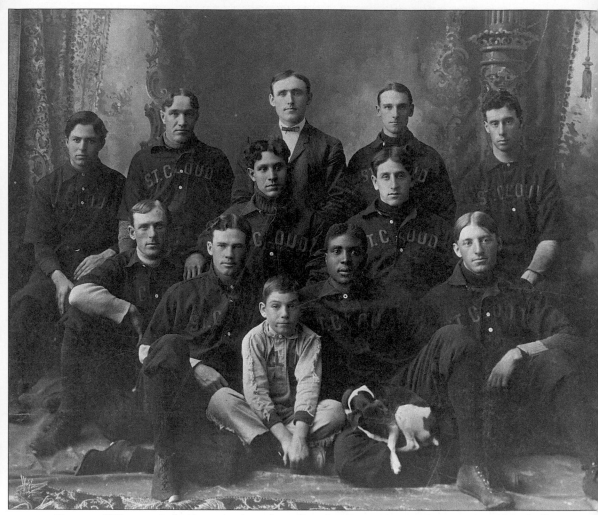

George Wilson pitched a single game for the Page Fence Giants in 1895, before finishing the season in the Michigan State League where he registered a record of 29-4 while hitting .327. He returned to the Fence Giants the following year and stayed with the team through 1898. He later played for Columbia Giants in 1899-1900 and the Chicago Union Giants from 1901-1905. Shown here with the St. Cloud, Minnesota team of 1903, seated, from left to right: Bill Miner, Cy Bennett, John Dominik, Orvil Kilroy, George Wilson, and boy mascot, Cliff Baldwin. Standing, from left to right, ? Meyers, ? Tucker, (John Pattison, mgr.,in suit), Frank Brigham and Sam Foster. (Courtesy of National Baseball Hall of Fame.)

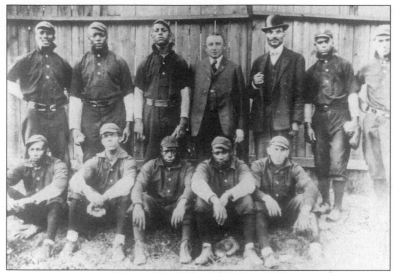

While pitching for the Philadelphia Giants in 1904, Foster beat his former team, the Cuban X Giants, twice in the championship series. He struck out 18 batters in one game, breaking the major league record of 15. The Philadelphia Giants, from left to right (front row) Dan McClellan, Pete Hill, Tom Washington, Mike Moore, and Bill Monroe; (back row) Grant Johnson, Rube Foster, Emmett Bowman, Walter Schlicter, Sol White, Pete Booker and Charlie Grant. This team finished the season with 81 wins, 43 losses and two ties. (Courtesy of NoirTech Research Inc.)

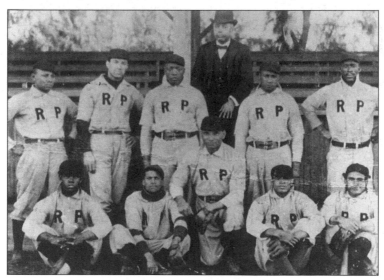

During the winter months, many players, including Rube Foster, went south to play in Florida for such teams as the Royal Poinciana Winter League Club of Palm Beach, Florida. The players of the 1904 team, from left to right, (front row) Pete Hill, Bill Monroe, Sol White, Big Bill Smith, Charlie "Chief Tokohoma" Grant; (back row) Dan "No-Hit" McClellan, unidentified, Andrew "Rube" Foster, H. Smith, Mike Moore, and Grant "Home Run" Johnson. The previous year, McClellan had pitched a perfect game against the Penn Athletic Club of York, PA, champions of the Tri-State League. (Courtesy of Jay Sanford.)

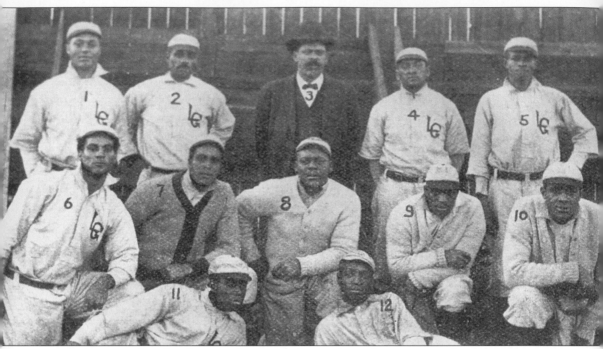

In 1905, Frank Leland created one of the trademark teams in Chicago history, the Leland Giants. The initial roster included (1) Dell Matthews, (2) George Taylor, (3) Leland, (4) David Wyatt, (5) Bruce Petway, (6) Charles Joe Green, (7) Walter Ball, (8) Andrew Campbell, (9) Dangerfield Talbert, (10) William Horn and (11) James Smith. Wyatt was later instrumental in co-drafting the constitution for the Negro National League in 1920. (Courtesy of Dick Clark.)

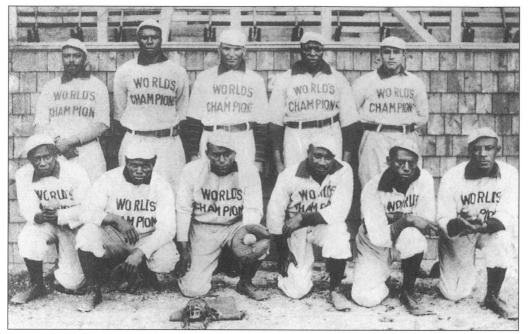

In 1906 Rube Foster was still with the Philadelphia Giants. They advertised themselves as the "World Colored Champions," and they were. Pictured above, from left to right: (front row) Danny McClellan, Pete Hill, Pete Booker, Grant "Home Run" Johnson, Emmett Bowman, and unidentified; (back row) unidentified, unidentified, Sol White, Rube Foster and Charlie Grant. (Courtesy of NoirTech Research Inc.)

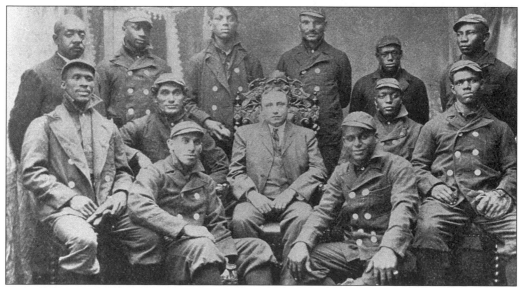

The 1906 Philadelphia Giants smirk in their double-breasted studio uniforms. They are, from left to right: (front row) Bill Monroe and Pete Booker, (middle row) Grant Johnson, Charlie Grant, Walter Schlicter, Rube Foster and Pete Hill, (back row) H. Smith, Mike Moore, Emmett Bowman, Sol White, Tom Washington and Dan McClellan. (Courtesy of National Baseball Hall of Fame.)

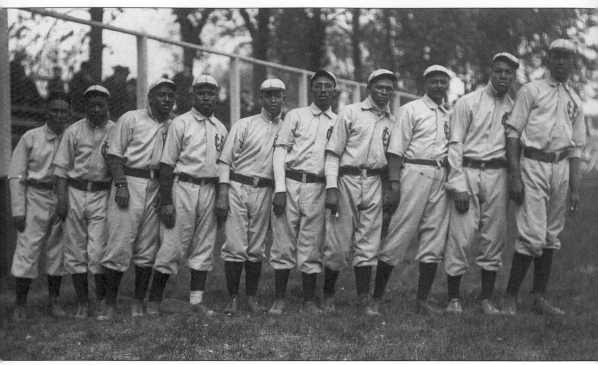

The Chicago Union Giants of 1905 won 112 games and lost only 10. The players are, from left to right: Bill Irwin, Willis Jones, Fred Roberts, Haywood Rose, Tom Washington, Harry Hyde, Clarence Lyttle, George Hopkins, George "Chappie" Johnson, and George Taylor. William S. Peters, former first baseman for the Unions, managed the team. (Courtesy of Chicago Historical Society.)

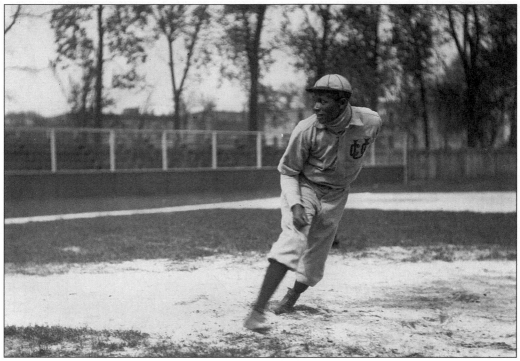

These photos taken in 1905 show Lyttle's pitching form with the Union Giants. The next year Lyttle played for the Leland Giants. After the season, he disappeared from the baseball scene, never to return. His whereabouts remain a mystery. (Courtesy of Chicago Historical Society.)

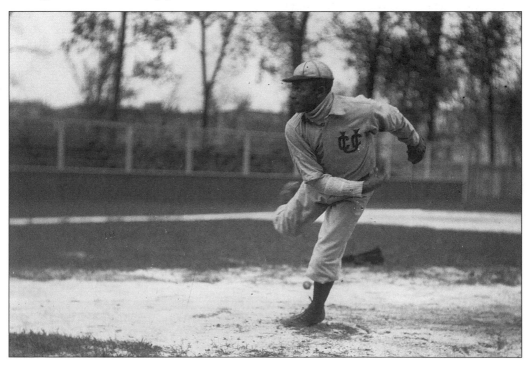

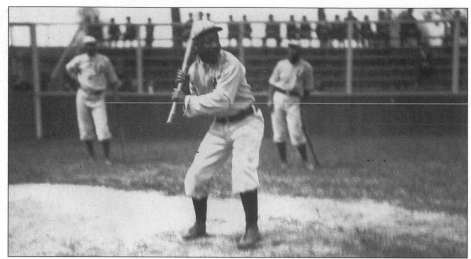

Willis "Will" Jones is pictured above taking batting practice. He was the regular right fielder for the Chicago Unions for eight straight seasons from 1895 through 1902, when the team's name changed to the Chicago Union Giants. Interestingly, Jones is using the gapped handgrip at the plate that the legendary Ty Cobb would make famous when he began his major league career in 1906, one year after this picture was taken. (Courtesy of Chicago Historical Society.)

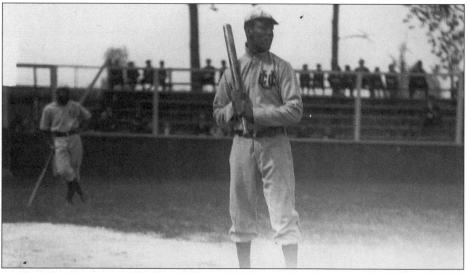

George "Chappie" Johnson was one of the greatest catchers in black baseball during the first quarter of this century. Johnson was with the Page Fence Giants from 1896 to 1898, the Chicago Columbia Giants from 1899-1900, and the Chicago Union Giants from 1901-1902. After spending the next several seasons barnstorming, Johnson returned to the Windy City to play for the Leland Giants in 1909 and later the newly-formed Chicago Giants in 1910. In addition to being a great handler of pitchers, Johnson was highly regarded as an instructor and teacher. Overcoming racial prejudices of the time, he was hired by the minor league American Association's St. Paul team to act as a coach in spring training from 1907 through 1912. (Courtesy of Chicago Historical Society.)

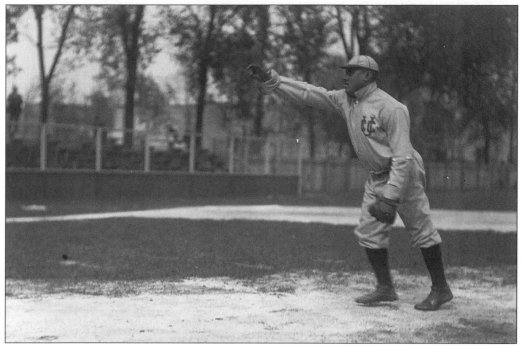

The career of Joe Miller, pictured here in a Chicago Union Giants uniform, moved right along with the evolution of early black baseball in Chicago. Miller played for the Page Fence Giants from 1895-1898. When the Fence Giants disbanded, Miller, along with several of his teammates, helped form the backbone of the Columbia Giants. Miller spent the 1899 and 1900 seasons, the only two years the team existed, with the Columbia Giants. Miller went on to play the next three years (1901-1903) with the Chicago Union Giants, the team formed when Frank Leland merged Miller's Columbia Giants with the Chicago Unions. (Courtesy of the Chicago Historical Society.)

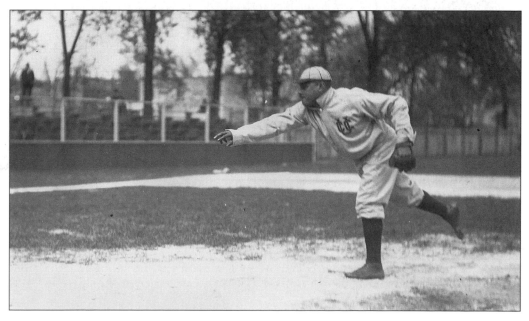

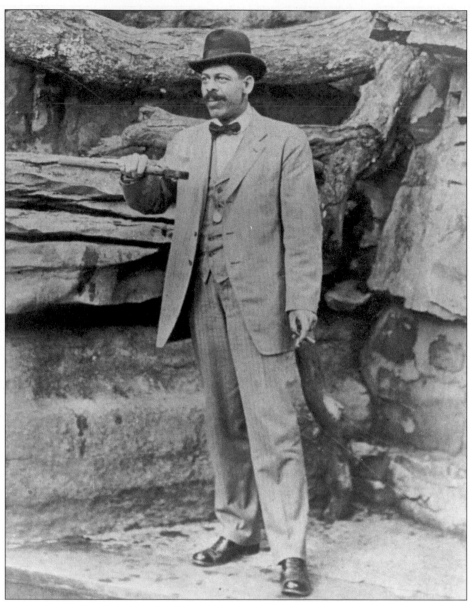

Frank C. Leland was one of the driving forces of black baseball in Chicago at the turn of the century. Leland started his Chicago baseball career as an outfielder with the Unions in 1887, which became the Chicago Unions in 1888, and remained at that position until 1889. In 1901, Leland combined the Chicago Unions with another Chicago-based team, the Columbia Giants, to form the Chicago Union Giants. In 1905, he formed another team, the Leland Giants, which he managed until he hired Rube Foster away from the Philadelphia Giants to act as a player/manager for the Leland Giants. This situation worked fine until 1910 when Foster split off from Leland. Leland, in response, formed the Chicago Giants. He lost the rights to the Leland Giants name in a court battle with Rube Foster. Leland never again enjoyed the success with the new team. He died in Chicago in 1914. (Courtesy of NoirTech Research Inc.)

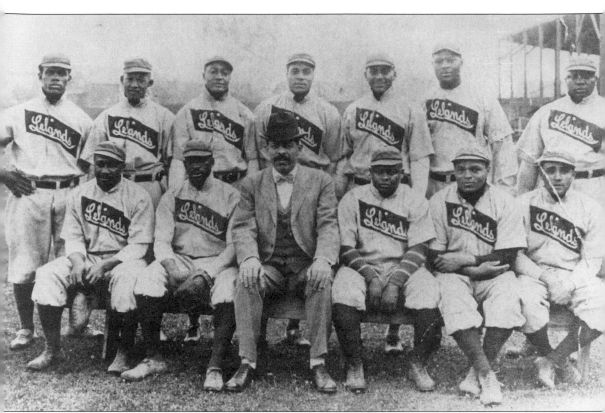

The 1909 Leland Giants of Chicago finished the season in first place with a record of 31-9 in the Chicago Baseball League. The players are, from left to right: (front row) Danger Talbert , Mike Moore, Frank C. Leland, Bobby Winston, Sam Strothers, and Nate Harris; (back row) Pete Hill, Andrew Payne, Pete Booker, Walter Ball, Pat Dougherty, Bill Gatewood, and Andrew "Rube" Foster. (Courtesy of Doris Foster.)

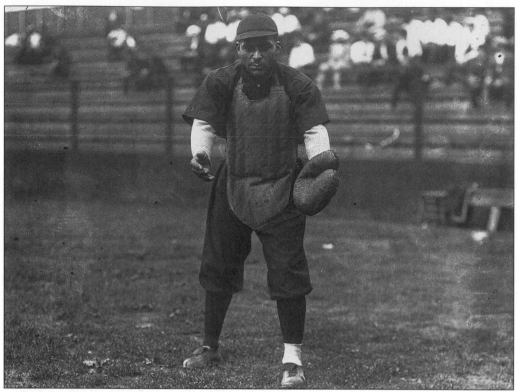

James "Pete" Booker played for the Leland Giants from 1907 through 1910. He was an outstanding receiver and later a fine first baseman for several years. Booker later played for the American Giants in 1914 and the Chicago Giants from 1915 to 1918. He was perhaps the best black catcher during the deadball era, before the arrival of Bruce Petway in 1911 with the Chicago American Giants. (Courtesy of Chicago Historical Society.)

George Washington Walter Ball, or the Georgia Rabbit, was born in Detroit in 1877. He joined the Grand Forks, ND, team in 1899 and won 25 of 28 games started, to help the team win the state championship. After appearances in Grand Forks and St. Cloud, Ball played with his first black team in 1903, the Chicago Union Giants. Perhaps his finest season was in 1909 with the Leland Giants, winning 25 games against one defeat. (Courtesy of Chicago Historical Society.)

This is what batters saw when they faced "Big Bill" Gatewood, shown here in a Leland Giants uniform. Gatewood, a master of the spitball and emery ball, was an excellent pitcher, a good hitter and a winning manager in his 28-year Negro League career. It was not only the talent of Gatewood that made batters wary of facing him, but the fact that he was known for throwing at hitters if he felt they needed a lesson in the game. Gatewood spent 1906 through 1909 with the Leland Giants, 1911 and part of 1912 with the Chicago Giants, and part of 1912 and 1915 with the Chicago American Giants. Chicagoans can be proud of the fact that Gatewood, who started his career in their city, went on to help develop the legendary Leroy "Satchel" Paige. In fact, it was Gatewood who taught Paige his famous hesitation pitch. (Courtesy of Chicago Historical Society.)

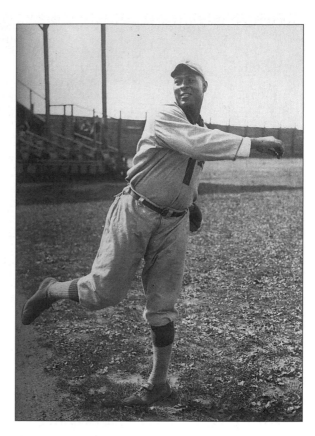

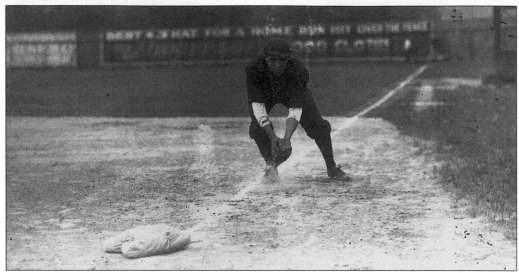

Nathan Harris of the 1909 Leland Giants started his career with the Pittsburgh Keystones in 1899 as a third baseman. Harris came to the Giants in 1905 and was the starting second baseman for many years. He often led the team in steals and runs scored. When Frank Leland reorganized the team in 1910, he named the steady, dependable Harris as captain. Harris retired in 1911. (Courtesy of the Chicago Historical Society.)

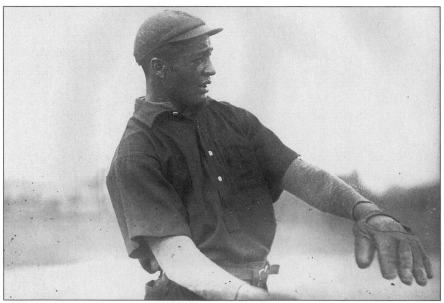

George Wright of the 1909 Leland Giants started his career in his hometown of Norfolk, with the Red Stockings in 1904. The shortstop played the next two seasons with the Brooklyn Royal Giants, making a brief appearance with the Philadelphia Quaker Giants at the end of the 1906 season. The next year he signed with the Leland Giants Baseball and Amusement Association. Wright played his final season with the Royal Giants in 1913. (Courtesy of the Chicago Historical Society.)

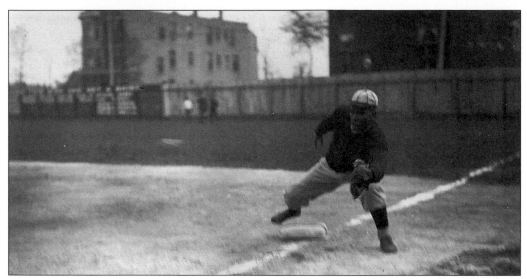

In this amazing picture catcher Haywood Rose shags a few tosses at first. Rose was known as the "backstop king" when he played for the Leland Giants in 1907. The fact that a picture of Rose existed, much less survived, for over nine decades is incredible since that it is the only known year that Rose played professional baseball. (Courtesy of Chicago Historical Society.)

John Henry "Pop" Lloyd, one of the greatest shortstops in the history of baseball, played for the Leland Giants in 1910 and the Chicago American Giants from 1914-1917. As a fielder, Lloyd had exceptional range and great hands, while at the plate he was as good as they came, hitting .417 in 1910. A lifetime .368 hitter Lloyd, who was called "the greatest player of all time" by Babe Ruth, was inducted into the Hall of Fame in 1977. (Courtesy of Dick Clark.)

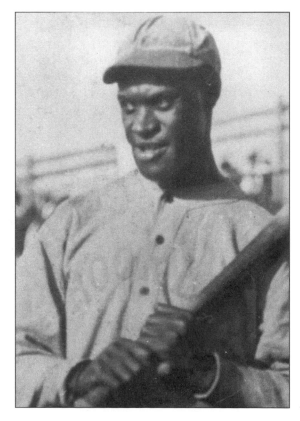

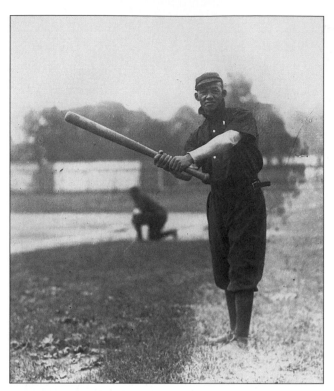

Andrew "Jap" Payne played for the Leland Giants from 1907 through 1910, the Chicago American Giants from 1911-1913 and the Chicago Giants in 1913. Payne was considered one of the best right fielders of his day. According to news reports of the day, there were "few better [at] cutting runners off at the plate. A complete package, Payne was a good hitter with some power and a master thief on the base paths." In 1953, Payne was named by Hall of Famer Pop Lloyd to his all-time team. (Courtesy of Chicago Historical Society.)

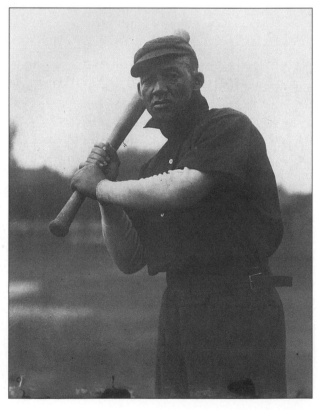

In 1903, Rube Foster headed east to play for the Cuban X-Giants out of New York. He posted a 51-4 record that season and in the fall, he posted four victories against the Philadelphia Giants to claim the "Colored Championship of the World". The nomadic Foster switched over to the Philadelphia team for the next three seasons. In 1907, Frank Leland appointed Foster player manager of his Giants. These photos were taken in 1909, the year Foster broke his leg against the Cuban Stars. Unable to pitch in the championship series against the St. Paul Colored Gophers, the Fosterless Giants lost the five-game series. (Courtesy of Chicago Historical Society)

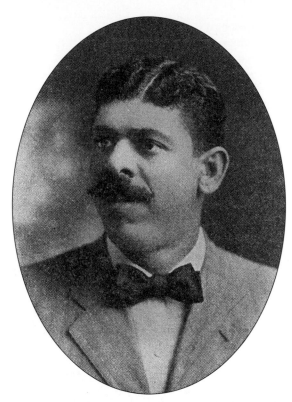

The demise of the original Leland Giants in 1909 signaled an end to an era in Chicago baseball. Frank Leland dissolved the partnership in September of 1909, selling his interest in the Leland Giants Baseball Club and Amusement Association to an investment company, owned by Chicago attorney Beauregard Moseley. Moseley retained Foster as captain and team manager of the Leland Giants. At the same time Leland re-incorporated a new team, renaming them the Leland's Chicago Giants Baseball Club. Now there were two teams in Chicago using the name of "Leland".

In an effort to retain the Leland name, Frank Leland filed a suit against Moseley in March of 1910 for $100,000 in copyright damages. The following month, Moseley won an injunction to block Leland's use of the name "Leland Giants," forcing Leland to name his re-organized club the Chicago Giants.

The ruling allowed Frank Leland's Chicago Giants to retain the services of Nate Harris, Charley Green, Bobby Winston, Harry Moore, George Wright, Chappie "Rat" Johnson, Bill Pettus, Walter Ball, Billy Norman and Dangerfield Talbert. They added Bob Marshall, Felix Wallace, James Taylor, and pitcher Johnny "Steel Arm" Taylor from the St. Paul Colored Gophers. Also coming over from the San Antonio Broncos was the talented Cyclone Joe Williams.

Meanwhile, Moseley and Foster retained the nucleus of the championship club and barnstormed across the Midwest capitalizing on the recognizable Leland Giant name. The split with Leland allowed Foster to sign Jimmy Booker, Grant Johnson, Wes Pryor, Pete Hill, Andrew Payne and battery mates, George Strothers (c) and Pat Dougherty (p). Foster enriched the roster by adding Pop Lloyd and superb signal caller, Bruce Petway from the Philadelphia Giants. In addition, right-handed fastball pitcher, Frank "Red Ant" Wickware joined the team.

Two
THE FOSTER YEARS, 1911-1930

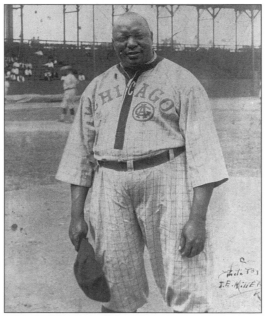

The Negro Leagues enter a new era with Foster's takeover of the Leland Giants. Rube Foster's Hall of Fame plaque states that he was "rated foremost manager and executive in [the] history of Negro Leagues." It is a fitting but lacking tribute. The groundwork that Foster laid with his Negro National League was the blueprint for all other black leagues to follow it. Foster was the man that began construction of the journey that eventually carried Jackie Robinson to Brooklyn in 1947. (Courtesy of NoirTech Research Inc.)

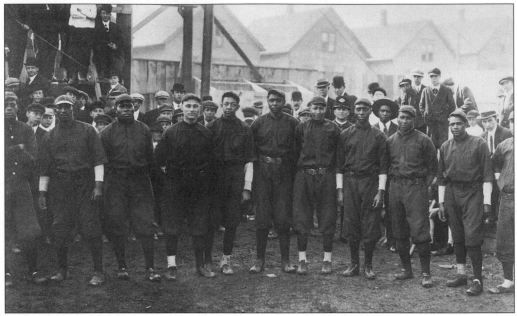

One of the top independent teams since 1886 was W.S. Peters' Chicago Union Giants. In the early days they played at 67th and Langley Avenue, before moving to 37th and Butler Streets in 1894. Along with the Frank Leland, Will Peters assembled some of the best nineteenth century Chicago teams. This team, circa 1913, toured the states of Indiana, Wisconsin, Michigan and Iowa, beating all comers. (Courtesy of the Golda Meir Library, University of Wisconsin.)

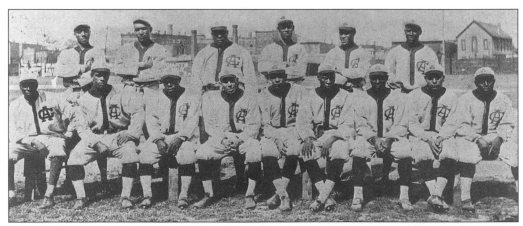

This photo presents the 1914 version of Rube Foster's Chicago American Giants. The Giants are, from left to right: (front row) George "Chappie" Johnson, Pete Hill, Bill Francis, William Monroe, Horace Jenkins, Bill Lindsay, Jack Watts, James "Pete" Booker, Frank "Pete" Duncan; (back row) Lee Wade, Jess Barbour, Andrew "Rube" Foster, Albert "Hamp" Gillard, John Henry "Pop" Lloyd, and Robert "Jude" Gans. (Courtesy of NoirTech Research Inc.)

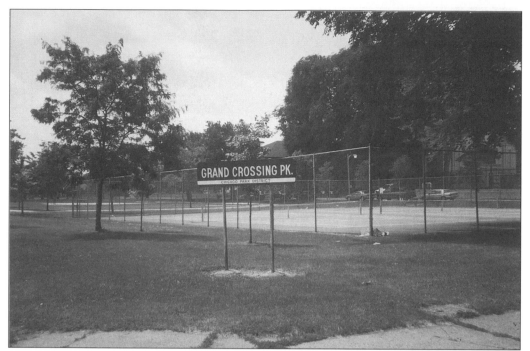

Grand Crossing Park, near 76th and Cottage Grove as it appears today, was used by black teams during the latter part of the 19th century. The practice of using local parks as home fields was a common practice in the Negro Leagues. The Chicago American Giants used Normal Park, which still exists at 69th and Halsted, as a home field in the 1920's. (Courtesy of Jerry Malloy.)

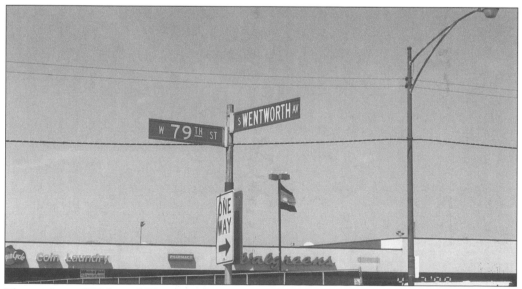

The corner of 79th and Wentworth was once the site of Auburn Ball Park. First used as a home field in 1901 by the Union Giants, it later became home to the Leland Giants and later the Chicago American Giants in the 1920s. During its use, a general admission seat cost 25¢. (Courtesy of Jerry Malloy.)

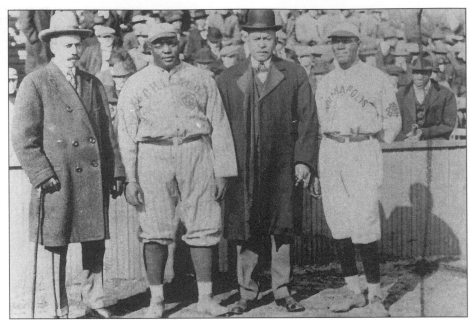

Pictured at the 1916 "Colored Championship" game, from left to right: Elwood Knox, Rube Foster, J.D. Howard, and C.I. Taylor. Taylor's Indianapolis ABC's would defeat Foster's American Giants for the championship that year. The American Giants would go on to win every pre-league "championship" from 1910-1919, with the exception of the 1916 title. Knox would later co-draft the Negro National League's constitution, while Howard was currently publisher of the *Indianapolis Ledger*. (Courtesy of Larry Hogan.)

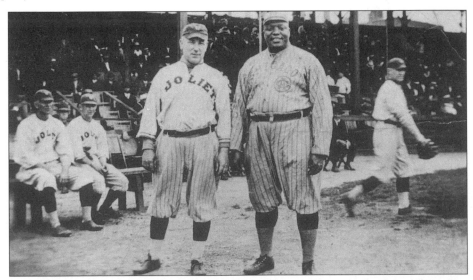

Besides playing for the colored championship, as it was known in those days, Foster's American Giants often played white teams to pick up an extra payday and fill a void in the schedule. When they couldn't find teams of the ABC's caliber or teams from the city league, they would travel to a remote location like Joliet to take on the town's best players. (Courtesy of NoirTech Research Inc.)

Dave Brown, who pitched for the Chicago American Giants from 1918-1922, was one of the finest left handed pitchers in the game. Brown was involved in a robbery in 1918, forcing Rube Foster to put up a $20,000 bond for his release. From 1920-1922, Brown had an outstanding record of 29 wins and 8 losses. Suspected of murder in 1925, Brown dropped out of sight. He was last seen pitching under the alias of Lefty Wilson for a team in Bertha, Minnesota, in the late twenties. (Courtesy of NoirTech Research Inc.)

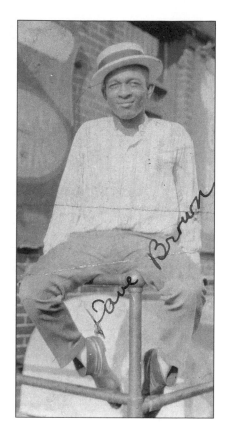

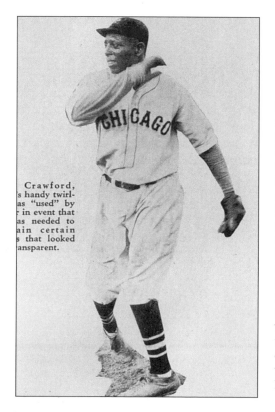

Crawford, s handy twirl- as "used" by r in event that as needed to ain certain s that looked ansparent.

Sam Crawford, in the middle of warming up, is considered one of the finest hurlers in black baseball from the dead ball era between 1910 and 1920. Crawford, who is remembered as having both a good fastball and knuckler, spent the majority of his career with Chicago-based teams. He was with the Chicago Giants in 1912, the year he pitched two no-hit games in one day, the Chicago American Giants from 1913-19 and again from 1925-28, the Chicago Columbia Giants in 1931, and Cole's American Giants in 1937. In addition to being a fine pitcher, Crawford also played outfield and second base, as well as being a manager and a coach in the later part of his career. What became of Crawford after his career in baseball is unknown. (Courtesy of the National Baseball Hall of Fame.)

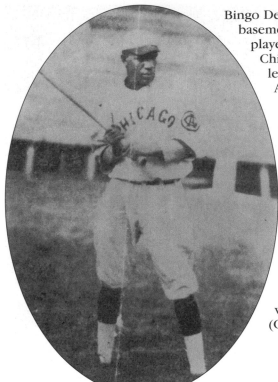

Bingo DeMoss was one of the greatest second basemen to ever play the game of baseball. He played for both the Chicago Giants and the Chicago American Giants in 1913 before leaving the city. He return to the Chicago American Giants in 1917 and stayed through 1925. While a complete ballplayer that regularly hit in the .300 range, a master on the bases, and a great hit and run man, DeMoss is remembered best for his stellar play at the keystone position. His great hands and excellent coordination made DeMoss a natural when it came to fielding the ball, but a strange gift put DeMoss a step above the rest. With the uncanny ability to know where he was on the field at all times, DeMoss could simply throw the ball to first base under his left arm without ever looking in that direction. (Courtesy of Dick Clark.)

During the 1917 and 1918 baseball season, the Chicago American Giants were home to one of the greatest black pitchers in history, "Cannonball" Dick Redding. An overpowering fast ball, hence the nickname, and good control helped Redding pitch an estimated 30 no-hitters during his career. In 1917, Redding, with his no wind up style of delivery, was the ace of the American Giants pitching staff, posting 13 wins and 3 loses that season. (Courtesy of Dick Clark.)

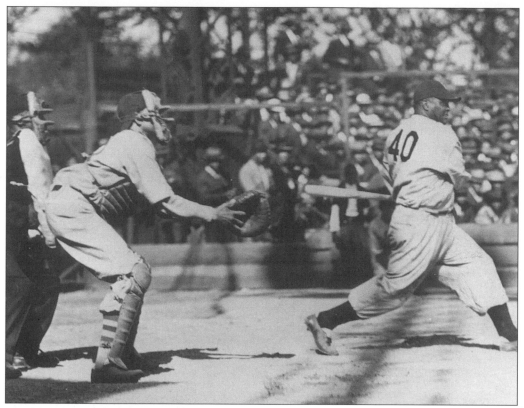

The Hall of Famer taking his patented swing is Oscar Charleston. He is believed, by many of his counterparts, to be the greatest Negro League player of all time and one of the best in the history of all baseball. Charleston, who played for the Chicago American Giants in 1919, was inducted into the Hall of Fame by the special Negro Leagues Committee in 1976. (Courtesy of NoirTech Research Inc.)

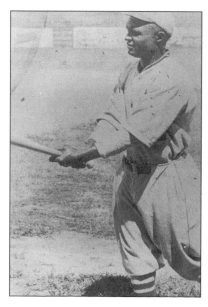

Hurley McNair started his career with the Chicago Giants in 1911. Small in stature at 5' 6", but big in the hitting department, mini-Mac was always among the leaders in home runs. Mac played almost three decades with a variety of teams, including the American Giants and the Kansas City Monarchs, before finishing his career in 1937 with the Cincinnati Tigers. McNair umpired after his playing days were over. (Courtesy of NoirTech Research Inc.)

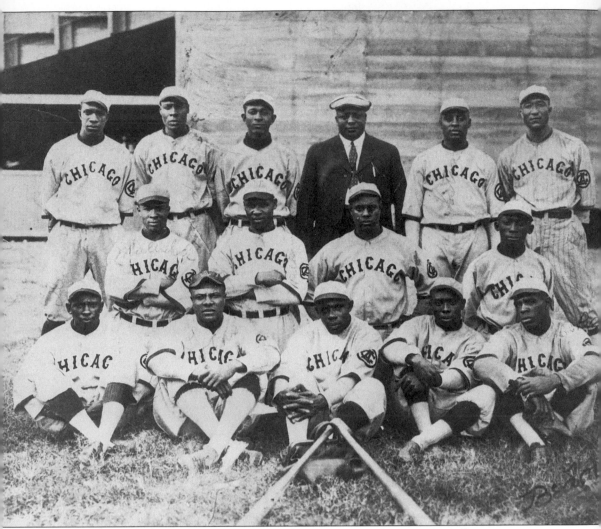

Rube Foster, the consummate professional, in suit and tie, is shown here with the 1919 version of his Chicago American Giants. Pictured from left to right: (front row) unidentified, Jimmie Lyons, Bill Francis, unidentified, unidentified; (middle row) Dave Malarcher, Bobby Williams, unidentified, John Reese; (back row) Elwood "Bingo" DeMoss, Leroy Grant, Dave Brown, Rube Foster, Oscar Charleston, and Richard Whitworth. (Courtesy of NoirTech Research Inc.)

The Wabash YMCA, located at 3763 South Wabash Avenue, regularly played host to members of traveling Negro League teams. Across the nation, YMCAs offered all the amenities of a hotel for a cheaper rate, so barnstorming or touring teams would often save money by lodging their players in the YMCA of the cities in which they were playing. (Courtesy of Jerry Malloy.)

This house at 712 East 44th Street was, in the hey day of the Negro Leagues, the Mabel Banks Boarding House. The use of boarding houses was a common practice by Negro League teams. Teams would usually stay at the same place each time it visited a city. As a result, the players in some boarding houses were looked upon as members of the family by the owners. (Courtesy of Jerry Malloy.)

Just as time has taken the majority of the men that played in the Negro Leagues from us, it has also taken the places where they played, both on and off the baseball diamond. This vacant lot on Indiana Avenue was once home of the top "race hotel" in the city of Chicago, the Franklin Hotel. Some of baseball's greatest black stars rested here before doing battle with Chicago's finest teams. (Courtesy of Dick Clark.)

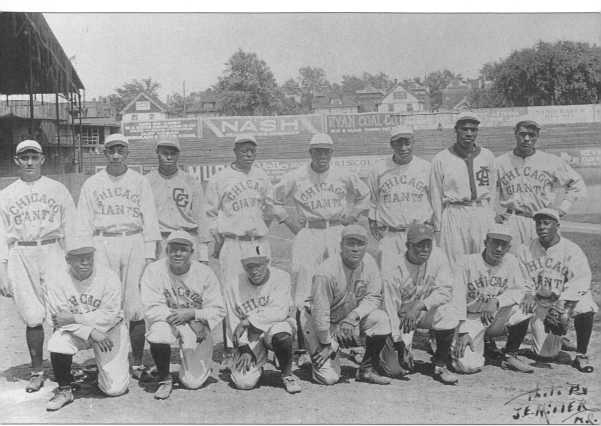

The Chicago Giants of 1920 finished last in the Negro National League with a record of 4-24. The players were, from left to right: (front row) Bob Winston, Bob Anderson, unidentified, Joe Green, unidentified, Willie Green, Jack Jennings; (back row) unidentified, Horace Jenkins, unidentified, unidentified, John Beckwith, Butler White, James Davis, and unidentified. (Courtesy of National Baseball Hall of Fame.)

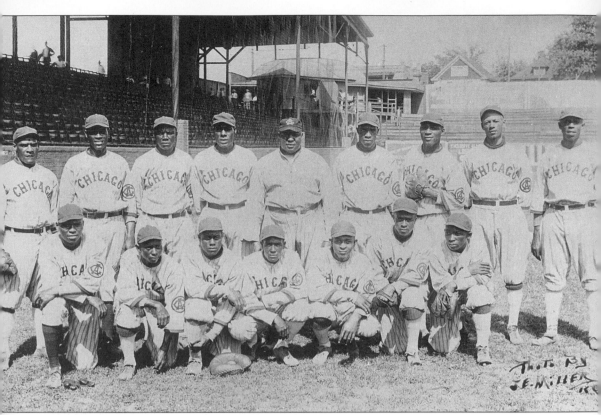

The 1920 Chicago American Giants, the team of the Negro National League founded by Rube Foster, fittingly enough, finished the league's inaugural year in first place, with a record of 35-13. The players are, from left to right: (front row) Jim Brown, Otis Starks, George Dixon, Dave Malarcher, Dave Brown, unidentified, John Reese; (back row) Cristobal Torriente, Tom Johnson, unidentified, unidentified, Rube Foster, Bingo DeMoss, Leroy Grant, Tom Williams, and Jack Marshall. (Courtesy of NoirTech Research Inc.)

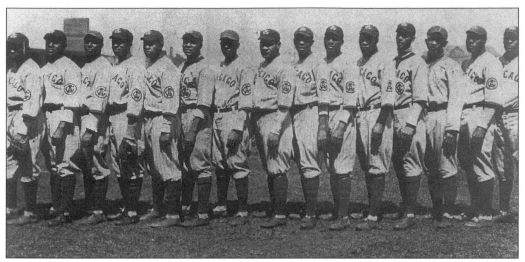

The 1921 Negro National League Champion Chicago American Giants won the NNL pennant with a record of 42-22. The players were, from left to right: John Reese, Otis Starks, Bobby Williams, Jelly Gardner, George Dixon, Jimmie Lyons, Dave Malarcher, Cristobal Torriente, Jack Marshall, Jim Brown, Bingo DeMoss, Tom Williams, Dave Brown, Leroy Grant, and Tom Johnson. (Courtesy of National Baseball Library.)

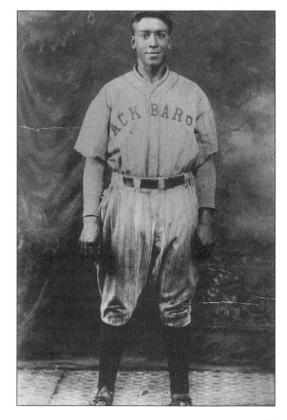

Although he was never a serious threat at the plate, Saul Davis, who played for the Chicago American Giants from 1925-1926 and 1929-1930, was a great defensive infielder. Equally adept at shortstop, second base, or third base, Davis had excellent range and a good throwing arm that made him a valuable contributor to the 1926 World Champion American Giants. (Courtesy of Saul Davis.)

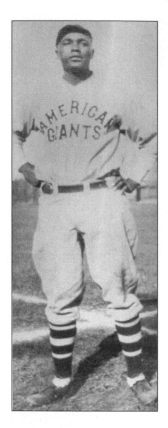

A four-sport letterman at Humboldt (Kansas) High School, George Sweatt joined the black leagues in 1921 with the Kansas City Monarchs. The clutch hitter outfielder brought his talents to the American Giants in 1926. He played in the Colored World Series with the Monarchs in 1924 and 1925, and the Giants in 1926 and 1927. This gave the part-time school teacher the distinction of being the only regular position player to play in the Negro National Leagues' first four October classics. (Courtesy of NoirTech Research Inc.)

Pitcher Webster McDonald, with his underhand delivery, played a major part in the 1926 and 1927 World Championship won by the Chicago American Giants. Referred to as "56 Varieties" because of his talent of mixing pitches, he went 14-9 in 1926 and 10-5 in 1927. McDonald joined the team in 1925 and left after the 1927 season. He returned again in 1929 and stayed for two seasons. He is shown here signing a petition circulated by the *New York Daily Worker* in 1939, to end segregation in baseball. (Courtesy of John B. Holway.)

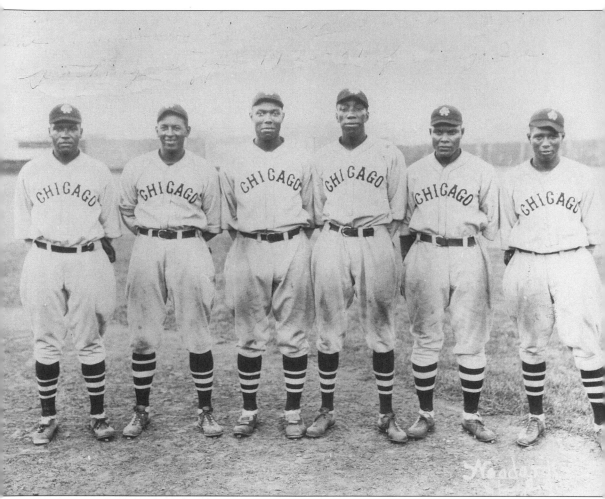

Members of the 1926 World Champion Chicago American Giants pitching staff are pictured here, from left to right: Webster McDonald, George Harney, Willie Foster, Rube Currie, Edward Miller, and Willie Powell. Members of the staff not pictured are Aubrey Owens and Robert Poindexter. (Courtesy of National Baseball Hall of Fame.)

Willie Hedrick Foster was the winningest pitcher in official Negro League games and brother of Rube Foster. When Rube refused to sign his brother to the American Giants in 1918, a rift developed between the two, which resulted in Willie returning to Mississippi until he signed with the Memphis Red Sox in 1923. Rube Foster, however, refused to let Willie pitch for anyone else, and exercised his power as head of the league and demanded the Memphis team send the younger Foster to Chicago. Oddly enough, once again, Rube Foster didn't fully support his younger brother, which resulted in Willie splitting the next three seasons between the American Giants and a team in the south. It was only after Dave Malarcher was manager that Willie Foster completed a full season in 1926 with the American Giants. (Courtesy of Luis Munoz.)

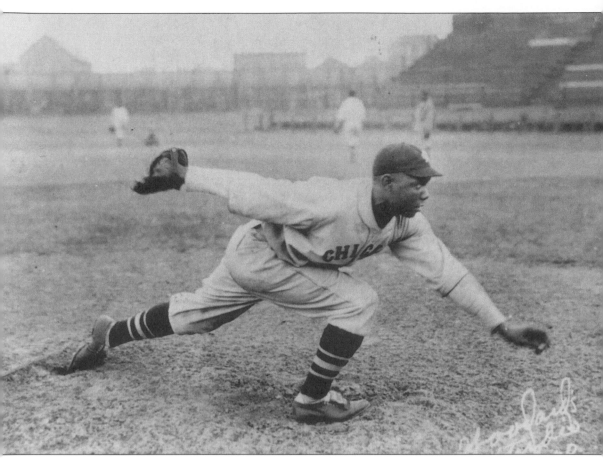

Following through after delivering a warm-up pitch is legendary Negro League pitcher Willie Foster. Once Willie Foster was able to perform on a regular basis, he worked his way to a record 137 wins in league games, the most of any pitcher in the history of the black baseball leagues. The younger Foster's career in the Negro League stretched from 1923 until the end of the 1938 season. He remained with the Chicago American Giants until 1930, leading the team to two world championships. He returned to play for the renamed Cole's American Giants from 1932 through 1935, and was back again with the renamed Chicago American Giants in 1937. Willie Foster became Dean of Men as well as baseball coach at Alcorn State College in Mississippi in 1960 and remained there until shortly before his death in 1978. (Courtesy of NoirTech Research Inc.)

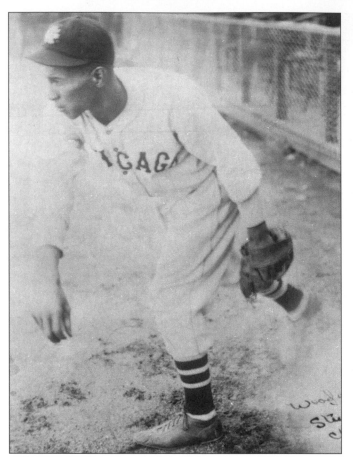

Pitcher Willie Powell was an integral part of the 1926 and 1927 World Champion American Giants. "Piggy" Powell had records of 10 and four in 1926, and 15 and six in 1927, including a no-hitter. In two Negro World Series, Powell started five games, winning two and losing one. (Courtesy of John B. Holway.)

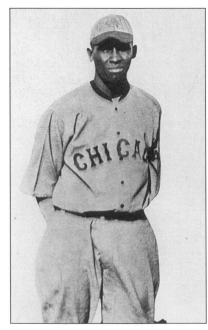

Outfielder and shortstop Stanford "Jambo" Jackson played for the Chicago American Giants from 1926-1930, and for the Chicago Columbia Giants in 1931. Jackson, according to legend, once ignored a sign from manager Rube Foster. When Jackson returned to the dugout, Foster verbally admonished Jackson and then, as if to drive the point home, Foster took his trusty pipe and cracked Jackson in the head. (Courtesy of Dick Clark.)

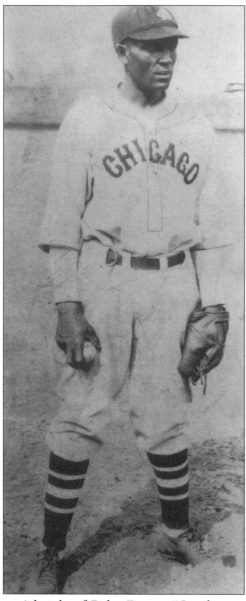

A student of the managerial style of Rube Foster, "Gentleman Dave" Malarcher took over the Chicago American Giants in 1926 after Foster was hospitalized. Malarcher, who had been with the team since 1920 as a third baseman, led the team to back-to - back World Championships, the only two the team would ever win. "Gentleman Dave" left the American Giants after the 1928 season, was with the Chicago Giants for the 1930 and 1931 season and returned to the now renamed Cole's American Giants in 1932, where he stayed through 1934. A fine fielder and hitter, best in clutch situations, he was also tough on the bases and was known to spike other players. He was always the gentleman, however, and would apologize afterwards. After retiring from baseball, Malarcher remained in Chicago and opened his own real estate business. (Courtesy of NoirTech Research Inc.)

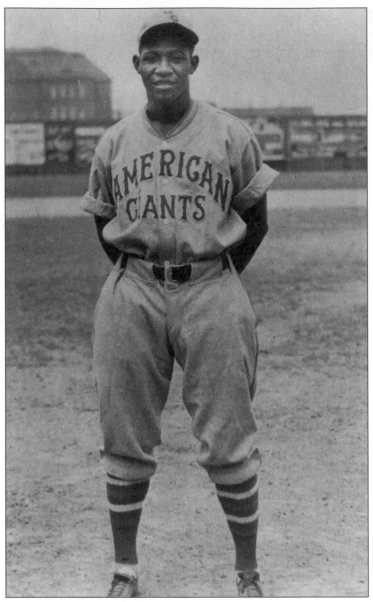

A member of both World Champion Chicago American Giants teams, 1926 and 1927, Lou Dials was a consistent .300 plus hitter and fine outfielder. Although he played for many teams during his Negro League career, Dials is most readily remembered and gained his greatest fame as a member of the Chicago-based team. He was with the American Giants from 1925 through 1928 and returned for two more seasons, 1936-1937. Dials and legendary Negro League pitcher Chet Brewer almost became historical figures as the men who broke the color barrier of organized baseball. The two were nearly signed in 1943 by the manager of the Los Angeles Angels, a minor league team in the Pacific Coast League. Chicagoan Philip Wrigley, who owned the team, refused to sign them. The American Giants in 1937 were the last Negro League team Dials played on. He moved on to the Mexican League from 1939 through 1941, and later on to semi-pro ball. (Courtesy of Lou Dials.)

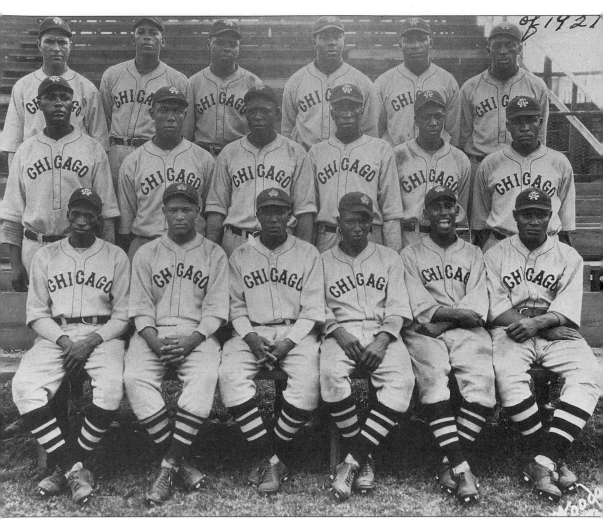

In 1927, the Chicago American Giants won their second consecutive World Championship. Pictured here, from left to right: (front row) Nat Rogers, Larry Brown, Dave Malarcher, Willie Powell, James Miller, Edward Miller; (middle row) George "Never" Sweatt, Willie Foster, Sam Crawford, Rube Currie, Bobby Robinson, Webster McDonald; (back row) John Hines, George Harney, Charles Williams, James Gurley, Jim Brown, and George Kobek. (Courtesy of National Baseball Hall of Fame.)

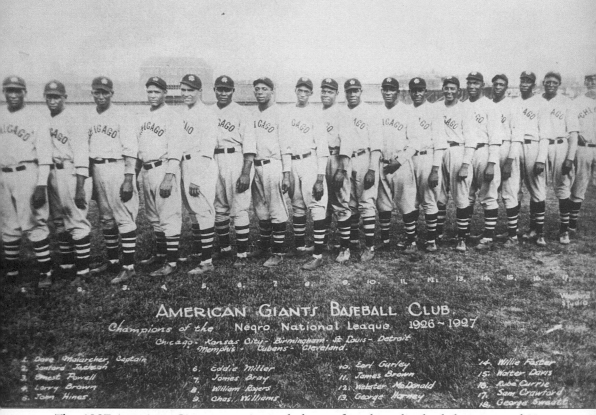

AMERICAN GIANTS BASEBALL CLUB.
Champions of the Negro National League 1926~1927
Chicago - Kansas City - Birmingham - St. Louis - Detroit
Memphis - Cubans - Cleveland.

1. Dave Malarcher, Captain
2. Sanford Jackson
3. Ernest Powell
4. Larry Brown
5. John Hines.

6. Eddie Miller
7. James Bray
8. William Rogers
9. Chas. Williams

10. Earl Gurley
11. James Brown
12. Webster McDonald
13. George Harney

14. Willie Foster
15. Walter Davis
16. Rube Currie
17. Sam Crawford
18. George Sweatt.

The 1927 American Giants are pictured above after they clinched their second Negro World Series championship, beating the Bacharach Giants in each series. They are, from left to right: captain Dave Malarcher, Stanford Jackson, Ernie Powell, Larry Brown, John Hines, Eddie Miller, James Bray, Nat Rogers, Ches Williams, Earl Gurley, James Brown, Webster McDonald, George Harney, Willie Foster, Walter Davis, Rube Currie, Sam Crawford and George Sweatt. (Courtesy of NoirTech Research Inc.)

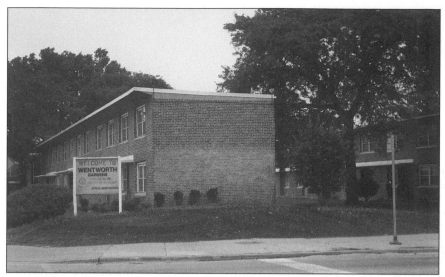

The Wentworth Garden Apartments, pictured here at the corner of 39th Street and Wentworth Avenue, occupy the site that was once Southside Park, home field to the Columbia Giants and the Chicago American Giants. Also known as Schorling Park, the field was the site of 12 Negro League World Series games between 1924 and 1927. The park was destroyed by a fire on Christmas Night, 1940. (Courtesy of Jerry Malloy.)

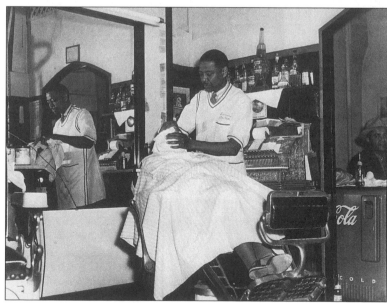

Managers and team owners demanded that their players look and act like gentlemen when they were not on the ball field. The place to go for a haircut and shave in black Chicago was the Metropolitan Barber Shop. Located at 4654 South Parkway, and owned and operated by Oscar Freeman, the multi-chair shop opened in 1928. (Courtesy of Jack Delano.)

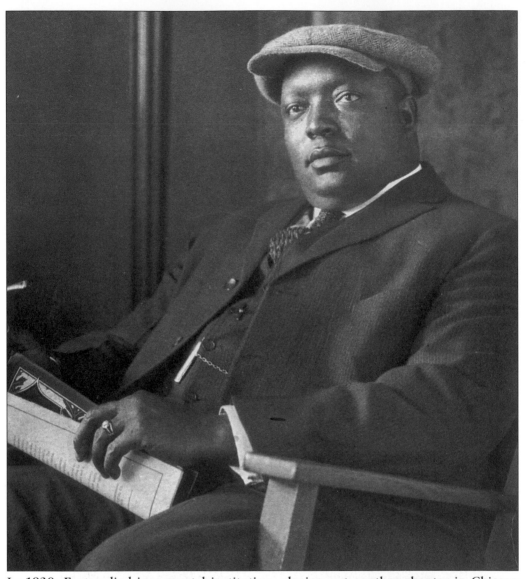

In 1930, Foster died in a mental institution, closing out another chapter in Chicago baseball history. His entrepreneurial efforts were best captured in this quote, "If the talents of Christy Mathewson, John McGraw, Ban Johnson, and Judge Kenesaw Mountain Landis were combined in a single body, and that body was enveloped in a black skin, the result would have to be named Andrew "Rube" Foster. As an outstanding pitcher, a colorful and shrewd field manager, and the founder and stern administrator of the first viable Negro League, Foster was the most impressive figure in black baseball history. From about 1911 until 1926, he stood astride Negro baseball in the Midwest with unchallenged power, a friend of Major League leaders, and the best known black man in Chicago. Rube Foster was an unlettered genius who combined generosity and sternness, the superb skills of a dedicated athlete and an unbounded belief in the future of the black baseball player. His life was baseball. Had he chosen otherwise, baseball would have been the poorer."–Robert Peterson in his landmark work "Only The Ball Was White."

Three

A NEW ERA FOR CHICAGO BASEBALL

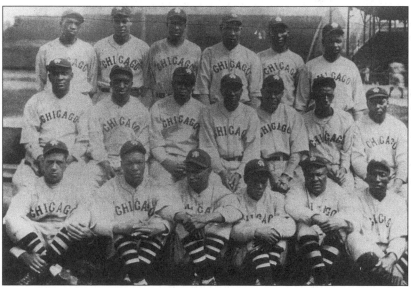

The 1932 Cole's American Giants are pictured above, from left to right: (front row) Norman Cross, Jack Marshall, Willie Powell, Malvin Powell, Jimmie Lyons, and Luther McDonald. Middle row, left to right, Pops Turner, Clarence Palm, Sandy Thompson, Dave Malarcher, Johnny Hines, F.B. Dixon, and Walter Harper; (back row) Nat Rogers, Kermit Dial, Walter Davis, Willie Foster, Turkey Stearnes, and Alex Radcliffe. In their first year under the new ownership of mortician Robert Cole, they won the Negro Southern League championship. (Courtesy of Malva Powell Smith.)

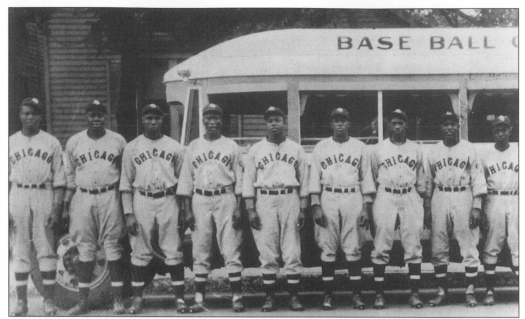

Pictured from the 1933 Cole's American Giants are, from left to right: Quincy Trouppe, George "Mule" Suttles, Willie Foster, Norman "Turkey" Stearnes, Alec Radcliff, unidentified, Nat Rogers, Willie "Devil" Wells, and unidentified. This picture shows the top two homerun hitters in official Negro League games. They were "Mule" Suttles, the all-time king, and "Turkey" Stearnes, in second place. (Courtesy of William F. McNeil.)

From 1936 through the 1939 season, the Chicago American Giants had the great curve ball artist, Ted "Highpockets" Trent. With his long curve, short curve, and shorter curve, Trent put together a record of 45 wins and only 13 losses. The six foot three inch right hander, who appeared in four consecutive All-Star games (1934-1937), died in the Windy City on January 10, 1944. (Courtesy of Dick Clark.)

Willie "The Devil" Wells, after Pop Lloyd, was perhaps the greatest shortstop in American Giants history. Wells played with Cole's American Giants from 1933 through the 1935 season, and for the Chicago American Giants in 1944. He was inducted by the Hall of Fame's Veterans Committee in 1997. (Courtesy of Dick Clark.)

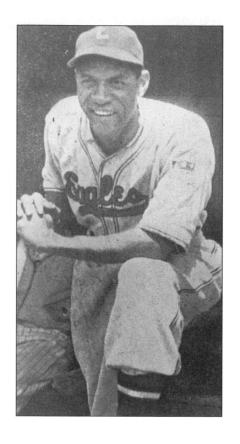

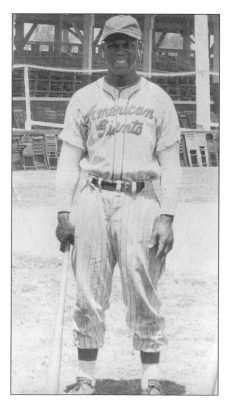

John Bissant began his career with Cole's American Giants in 1934 and later was an outfielder for the Chicago American Giants from 1939-1948. Bissant played all outfield positions as well as second base, with a little spot-pitching during his career in the Negro Leagues. (Courtesy of NoirTech Research Inc.)

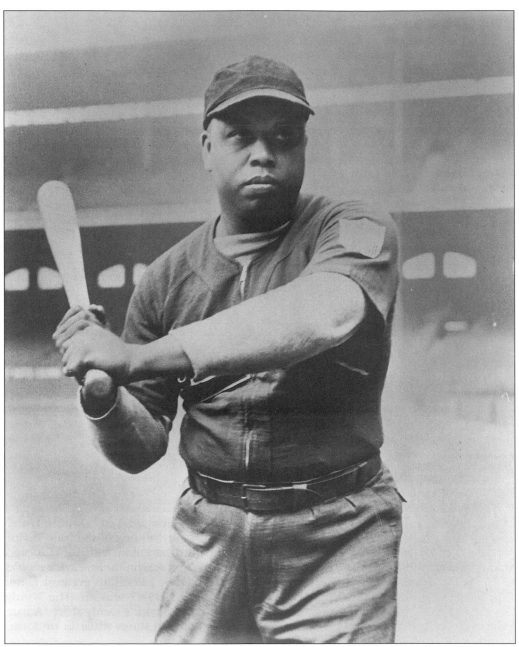

Although he played for several teams during his career, Alexander "Alec" Radcliffe is best remembered as the slugging third baseman of the Chicago American Giants from 1936-39, 1941-44, and again in 1949. With his 40-ounce bat, Radcliffe set the record for most at bats and hits in the East-West All-Star game, and finished second behind Buck Leonard in RBIs. Radcliffe also played for the Chicago Giants and Cole's American Giants. After retiring from baseball, Radcliffe owned and ran a bar in Chicago. One of the bartenders was his brother, Double Duty. Some historians consider Alec the best third baseman to play in the Negro American League. (Courtesy of NoirTech Research Inc.)

This sharply dressed man is the debonair Art "Superman" Pennington who played with the American Giants from 1940-1946 and again in 1950. The versatile Pennington played every position, with the exception of catcher, though he felt most at home in the outfield. The switch-hitting Pennington was a solid hitter with good power, and sported a lifetime .336 batting average for his eight years. Pennington, like many other Negro Leaguers, as well as a number of major league players, spent the late 1940s playing in the Mexican baseball league. From 1951-1959, "Superman" played in the minor leagues but never got the call to the majors, despite winning the Three-I League batting title in 1952 with an average of .349. The following two seasons Pennington posted averages of .329 and .345 in the league. (Courtesy of National Baseball Hall of Fame.)

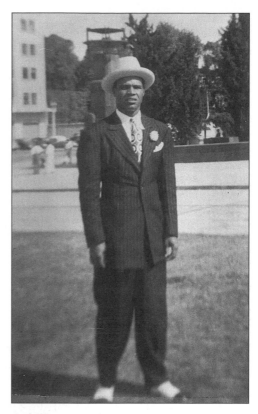

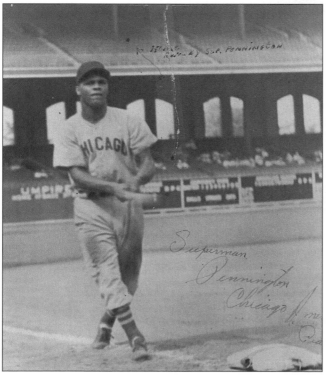

Escaping from his phone booth in Chicago's original Comiskey Park in 1943 is American Giant Art "Superman" Pennington. Visible on the second deck of the stadium are the inscribed words "Home run by Sup. Pennington." To reach the spot marked where the home run landed, the ball would have traveled roughly 400 feet from home plate. (Courtesy of National Baseball Hall of Fame.)

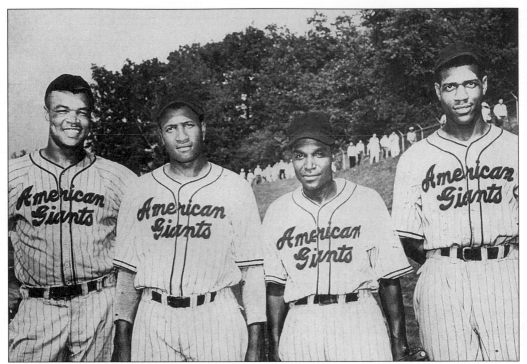

Members of the 1941 Chicago American Giants are pictured, from left to right: Pepper Bassett, Willie Ferrell, Jimmie Crutchfield, and Willie Henderson. Bassett, a catcher, played for the American Giants from 1939-1941, and made eight appearances in the East-West All-Star game during his 17-year professional career. A steady catcher, Bassett was a good handler of pitchers, with a great arm and a top hitter whose batting average regularly ventured into the .300 range. (Courtesy of NoirTech Research Inc.)

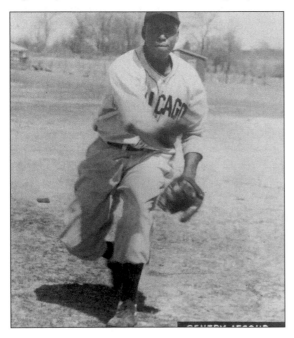

Gentry Jessup, in an American Giants uniform, was a major cog in their pitching staff in the 1940s. Jessup was with the team from 1941 through the 1949 season, and was chosen to five East-West All-Star squads, He also played with Satchel Paige's barnstorming All-Stars, in 1946. On May 12, 1946, he pitched all 20 innings against the Indianapolis Clowns, for a 3-3 tie at Comiskey Park. After retiring from pro sports, he worked at Continental Can in Chicago. (Courtesy of NoirTech Research Inc.)

The 1941 Chicago American Giants grin for the camera at Muehlebach Field in Kansas City, Missouri. Pictured from left to right: (front row) Oscar Boone, Johnny Lyles, Curtis Henderson, Candy Jim Taylor, Jimmie Crutchfield, Bill Horne and Sug Cornelius; (back row) Willie "Toots" Ferrell, Henry "Speed" Merchant, Don Reeves, Willie Hudson, Unidentified, Lloyd "Pepper" Bassett, Alvin Gipson, Art Pennington and Ted Alexander. (Courtesy of National Baseball Hall of Fame.)

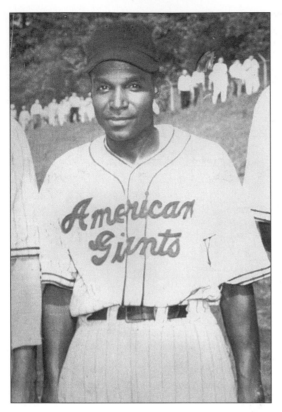

If an outfield had Colonel Jimmie Crutchfield, it was top quality. The talented flyhawk with warp speed, played with the American Giants from 1941-1942 and from 1944-45. Discovered by Bill Gatewood, they gave him a 100-to-1 shot of making the black leagues. Crutch said, "I was told I would never be able to hit Ted Trent, Satchel Paige or Willie Foster, because of my size. But I did!" After retiring a 16-year career in baseball, Crutchfield stayed in Chicago, where he worked for the postal service for 26 years. (Courtesy of Bucket Number Six.)

Shown in a 1942 Chicago American Giants uniform is Hall of Fame member James "Cool Papa" Bell. It was a former American Giant, Big Bill Gatewood, who gave the famous flyer his nickname. While Gatewood was managing the St. Louis Stars, the rookie, Bell, who was a pitcher then, calmly struck out Oscar Charleston. Gatewood, stories say, commented that Bell was "one cool papa." This was Bell's only year with Chicago. (Courtesy of NoirTech Research Inc.)

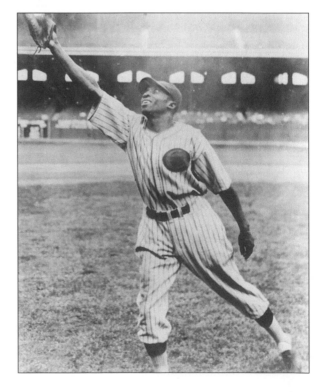

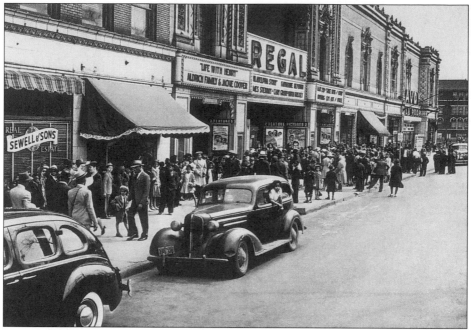

When not traveling or playing a game, a Negro League baseball player's life was not all that different from any other African American of that time. Movie palaces such as the city's Regal Theater, shown here in 1941, were popular stops for ballplayers. Another popular endeavor was dancing at a place like the Savoy Ball Room, located just down the street from the Regal. (Courtesy of Russell Lee.)

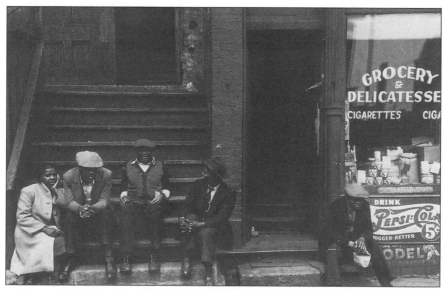

Bronzeville residents passing the time chatting in 1941. The black districts were, in many ways, a city within a city. Anything found in the white sections of a town could be found in the African American areas. The fact that the hospitals, theaters, grocery store, and baseball teams were run by, and for blacks, kept the wall of segregation rigid for several years. (Courtesy of Russell Lee.)

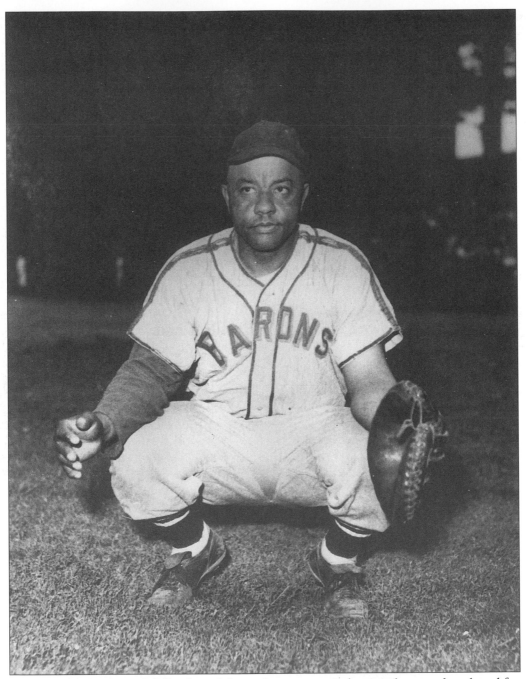

Ted "Double Duty" Radcliffe, the celebrated one-man pitcher/catcher combo played for the Chicago American Giants. Radcliffe got his nickname after sportswriter Damon Runyon saw him catch the first game of a doubleheader in Yankee Stadium in 1932 and then pitch a shut out the second game. Reportedly, Radcliffe's chest protector bore the warning "Thou Shalt Not Steal." (Courtesy of Wayne Stivers.)

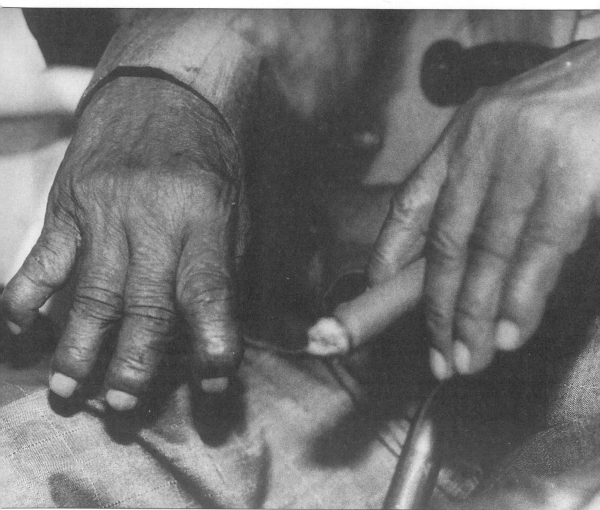

These are the hands of the man who caught Satchel Paige's no-hitter and many other stellar pitching performances for close to 30 years. They call him Double Duty for his ability to catch and/or pitch on a moment's notice. Formally known as Theodore Roosevelt Racliffe, from Mobile, Alabama, he played several seasons with the American Giants, 1934, 1941-43, and 1949-51. (Courtesy Lisa Feder.)

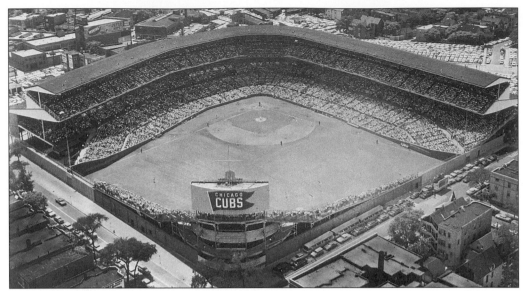

There are times in professional sports when a single event, due to the participants, actually proves bigger than the hype. Two such games took place in Chicago's Wrigley Field under the title of Satchel Paige Day. Both games, one in 1942 and the other in 1943, pitted the legendary Satchel Paige against the best black left-handed pitcher of the forties, Verdell "Lefty" Mathis of the Memphis Red Sox. (Courtesy of NoirTech Research Inc.)

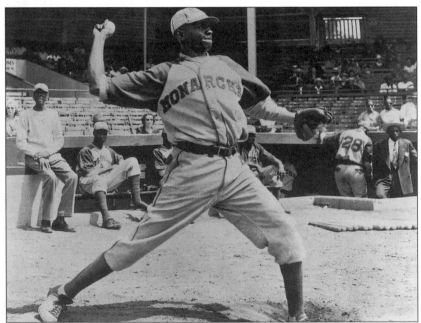

On Satchel Paige Day in July of 1942, with 20,000 fans, Paige and the Kansas City Monarchs defeated Mathis and his Memphis Red Sox by a score of 4-2. Paige gave up seven hits and struck out six in seven innings before the game was called on account of darkness. (Courtesy of NoirTech Research Inc.)

The following year, in July 1943, thirty thousand fans witnessed the second Satchel Paige Day as Verdell Mathis and his Red Sox of Memphis defeated Paige who was playing that day with the New York Cubans. The Red Sox won by a score of 2-1, with Mathis gaining an extra measure of revenge by driving in the winning run. (Courtesy of NoirTech Research Inc.)

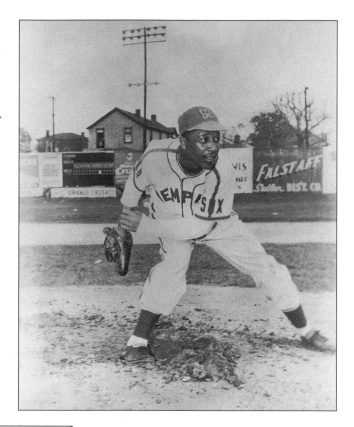

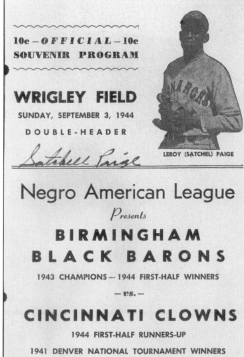

10c – OFFICIAL – 10c
SOUVENIR PROGRAM

WRIGLEY FIELD

SUNDAY, SEPTEMBER 3, 1944

DOUBLE-HEADER

Satchell Paige

LEROY (SATCHEL) PAIGE

Negro American League

Presents

BIRMINGHAM
BLACK BARONS

1943 CHAMPIONS — 1944 FIRST-HALF WINNERS

— vs. —

CINCINNATI CLOWNS

1944 FIRST-HALF RUNNERS-UP

1941 DENVER NATIONAL TOURNAMENT WINNERS

The Walls of Ivy were used not only as a home field for the American Giants and the site of Satchel Paige Days, but also as a neutral field for Negro League games. The feature at this advertised Wrigley Field doubleheader in 1944 was Satchel Paige pitching for one of the four teams. Kansas City Monarchs owner, J. L. Wilkinson, regularly hired Paige out to help other teams meet their payroll. (Courtesy of Jeff Eastland.)

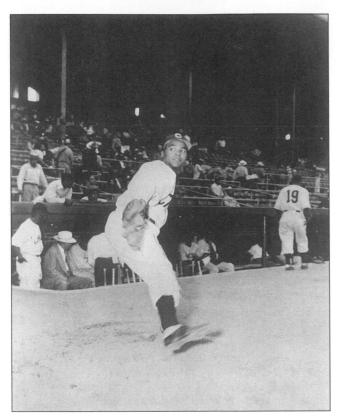

Harry "Lefty" Rhodes began his career with the American Giants in 1942 only to have it interrupted by World War II. Rhodes returned to the team in 1946 and remained a part of the pitching staff through the end of the 1950 season. Rhodes played in the outfield as well as first base. Rhodes recalled a rookie named Willie Mays making his debut with the 1947 Birmingham Black Barons. "He stole home his first day in the league," claimed Rhodes. (Courtesy of NoirTech Research Inc.)

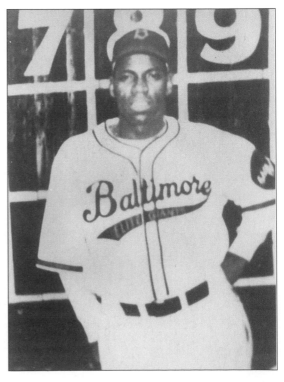

A versatile player with a good eye at the plate, Lester Lockett played for the Chicago American Giants in 1942 and in 1950. The Chicago resident could play second, third and shortstop equally well but was best remembered as an outfielder. Lockett played in four East-West All-Star games. During 1950, his last season in the Negro Leagues, at the age of 38, Lockett had a batting average of .301. (Courtesy of Dick Clark.)

Clyde McNeal, a shortstop and second baseman for the American Giants from 1944 through 1950, was discovered by Candy Jim Taylor off a local team in San Antonio, Texas, at the age of 16. McNeal was a good defensive player who was best at shortstop, where he had good range and a strong arm that allowed him to make all the plays. (Courtesy of Dick Clark.)

Outfielder and first baseman, Jesse Sharon Williams was a member of the 1944 Chicago American Giants. Sometimes he was confused with the more famous all-star infielder, Jesse Horace Williams, of the Kansas City Monarchs. He hit a home run in his first at bat. He also played with the Grand Rapid Jets in the minor leagues. After baseball, Williams became the first black manager with Beneficial Finance Corporation in 1963. (Courtesy of Jesse Williams.)

Pictured above are members of the Chicago Lumber Company of 1944. The hitters of the Chicago American Giants and their averages for that season were, from left to right: John Smith, .378, Lloyd Davenport, .304, Ralph Wyatt, .267, Jesse Douglas, .280, and Art Pennington, .299. The group couldn't generate enough power while the American Giants finished next to last in the Negro American League. (Courtesy of NoirTech Research Inc.)

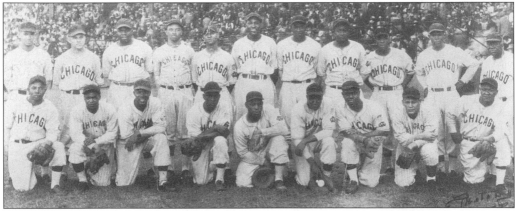

The 1947 American Giants finished next to last with a 31-50 win-loss record. Pictured above, from left to right; (front row) Tommy Turner, Lefty Rhodes, Clyde Nelson, Bernell Longest, Bill Charter, unidentified, Herman "Red" Howard, James Buckner, Willie "Sug" Cornelius; (back row) Clyde McNeal, Walter McCoy, Edward "Pep" Young, Jacob "Red" Robinson, Clarence "Dad" Locke, Chet Brewer, John "Mule" Miles, "Big" Jim McCurine, Ralph Wyatt, John Bissant, and James "Candy Jim" Taylor, manager. (Courtesy of NoirTech Research Inc.)

Future Chicago American Giant Thomas "Tommy" Turner (left) with Lt. James Chambers at Fort Huachuca, Arizona during World War II. Turner, a first baseman, signed with the American Giants in 1947. Captain of the army football and baseball teams, he also excelled at basketball and roller skating. Lt. Chambers called Turner, "… the greatest natural athlete I've seen in my life." (Courtesy of Thomas Turner.)

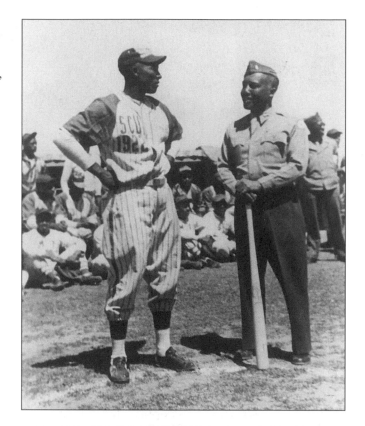

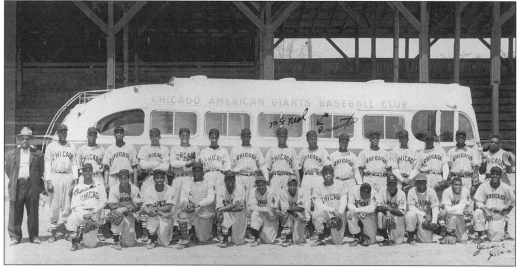

The 1948 American Giants finished dead last, winning 27 of 75 games, in the last credible year of the Negro American League. The next year, as the major leagues continued to siphon the cream of the crop from the black leagues, the American Giants signed three white players in a desperate attempt to boost attendance. Louis Chirban, Frank Dyll and Louis Clarizio became the first white players to play for the traditionally black Giants. (Courtesy of National Baseball Hall of Fame.)

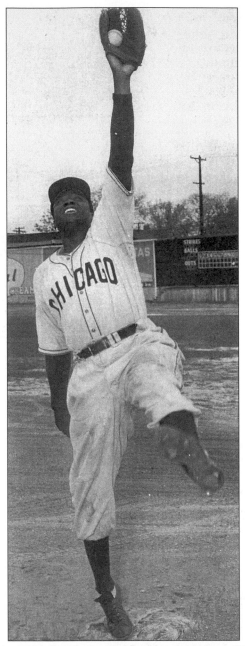

John Williams was the starting first baseman for the American Giants in 1948, when the team finished with a record of 27 wins and 48 losses. Although a good fielder, Williams was only a fair hitter. The occasional outfielder hit only .234 that season. (Courtesy of Marlin Carter.)

Benvienido "Benny" Rodriquez, from
Santa Isabel, Puerto Rico, spent his only
season in the Negro Leagues with the
1948 Chicago American Giants. A good
defensive player with an adequate arm,
he played outfield and catcher.
Rodriquez finished the season with a
.241 average. (Courtesy of NoirTech
Research Inc.)

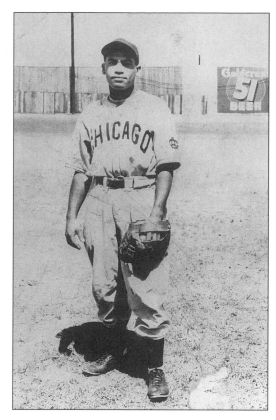

Riley Stewart was a pitcher for the
American Giants from 1946 through
the end of the 1949 season. Although
he only had a record of two wins and
eight losses in 1948, he did
contribute to the team's efforts with
a .343 batting average that season. A
graduate of Leland College in Baker,
Louisiana, he later became an
assistant principal at Bossier (LA)
Airline High School. (Courtesy of
Marlin Carter.)

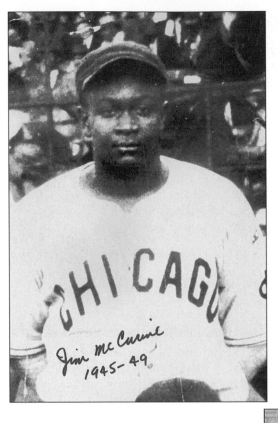

Outfielder James "Big Jim" McCurine played for the American Giants from 1946 through the 1949 season. McCurine, who played right field, left field, and occasionally third base, was a good defensive player, and, at times, a good hitter hitting for a .296 average in 1946. After retiring from baseball McCurine stayed in Chicago, where he still lives. (Courtesy of Marlin Carter.)

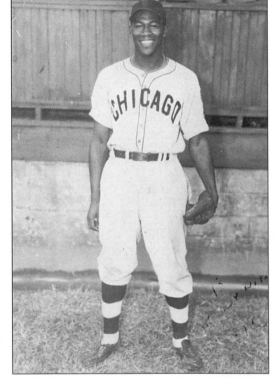

According to legendary manager Candy Jim Taylor, John "Mule" Miles "hit that ball like a mule kicks." An outfielder with a strong arm, "Mule" Miles played for the Chicago American Giants from 1946 through 1948. In 1947, he finished among the league leaders, hitting 26 homers while recording a .250 average. (Courtesy of John Miles.)

Don Johnson was a standout second baseman for the American Giants in the early fifties, and later for the Birmingham Black Barons and the Baltimore Elite Giants. Pat Patterson, Chicago's catcher, gave rookie Johnson the nickname of Groundhog, because of the way he rode low to the turf and gobbled up grounders. (Courtesy of Don Johnson.)

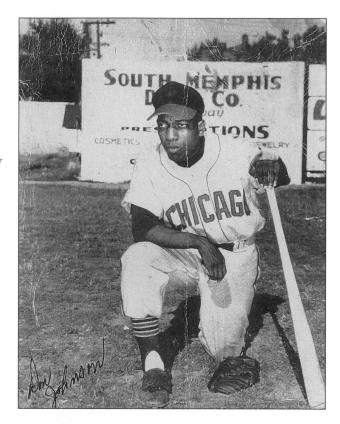

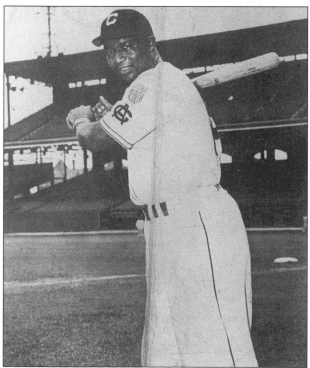

Lonnie Summers, who played for the Chicago American Giants from 1948-1949, and again in 1951, was a powerful line drive hitter who was at home either in the outfield or behind the plate. After leaving the American Giants, Summers played in the minor leagues in San Diego (California), Boise (Idaho), and Yakima (Washington). (Courtesy of Fanny Ware.)

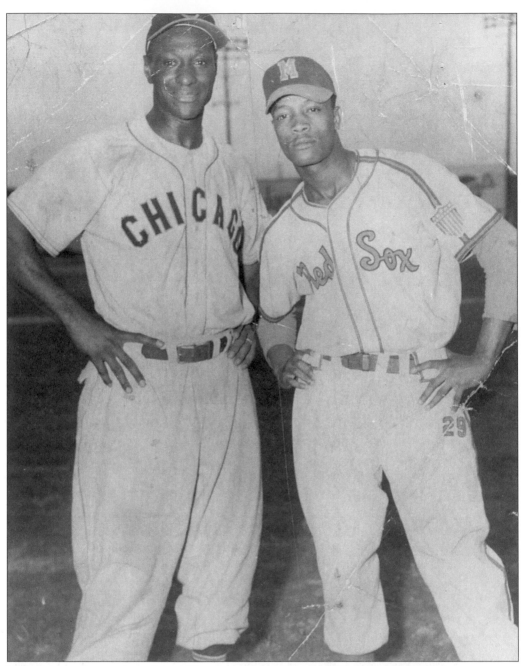

Ted Strong in an American Giants uniform, along with Joe Henry before a game. Strong, who was with the American Giants in 1951, was a complete ballplayer that could hit for both average and power and was a good fielder with a strong arm. During the off season, the six-time East-West All-Star was the western unit captain of the Harlem Globetrotters basketball team. (Courtesy of NoirTech Research Inc.)

Four
BLACK BASEBALL'S SIGNATURE EVENT

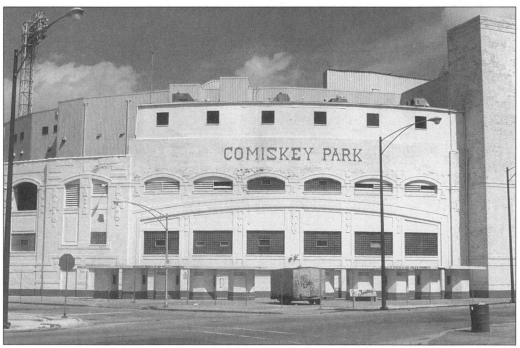

The original Comiskey Park, which served as the home of the Chicago American Giants and the Chicago White Sox, was also the home to the biggest event in Negro League baseball, the annual East-West All-Star game. Like its major league counter part, the East-West game was started in 1933, but unlike the majors, the East-West game did not travel to a different city each season. The event became a major Chicago attraction and a bigger draw than the Negro World Series. (Courtesy of NoirTech Research Inc.)

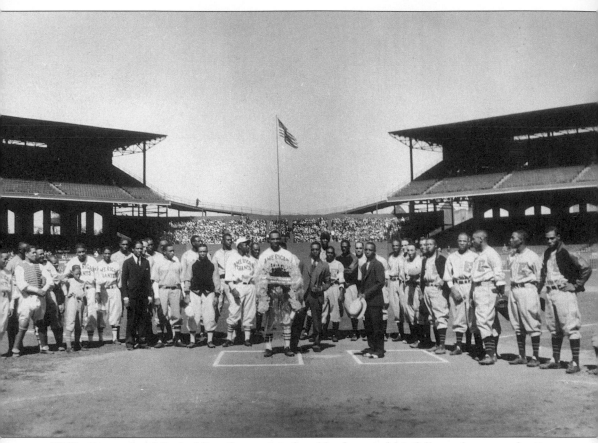

Willie Foster (middle holding flowers) is feted by fans and his fellow players at the East-West game in 1934. The ceremony was held to recognize his win in the first All-Star game the year before. Foster pitched all nine innings. It was the only time in the history of the East-West classic that a complete game was thrown. (Courtesy of NoirTech Research Inc.)

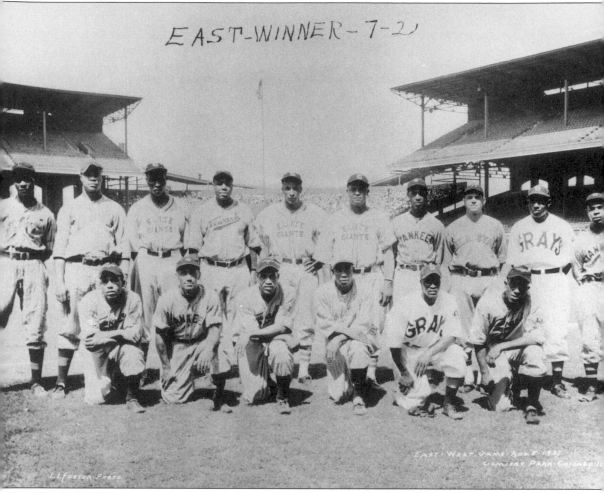

The 1937 East Squad is pictured above, from left to right: (front row) Ray Dandridge, Fats Jenkins, Willie Wells, Ches Williams, Jerry Benjamin, and Leon Day; (back row) Barney Morris, Pepper Bassett, Andy Porter, Mule Suttles, Bill Wright, Biz Mackey, Barney Brown, Jake Dunn, Buck Leonard, and Bill Holland. The East team, behind Morris' pitching, won by a score of 7-2. (Courtesy of NoirTech Research Inc.)

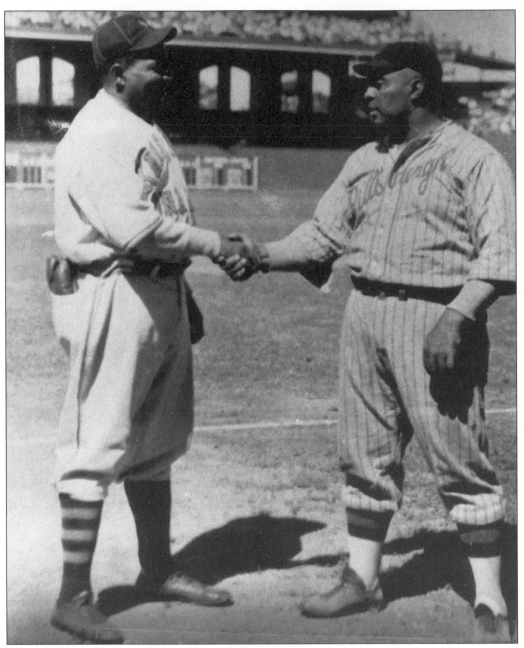

The 1938 East-West All-Star contest saw two of the game's greatest stars acting as team managers. West team manager Andy Cooper of the Kansas City Monarchs (left) and East team leader Oscar Charleston of the Pittsburgh Crawfords (right) shake hands before the teams come out fighting. Cooper's team squeezed out a 5-4 victory. (Courtesy of John B. Holway.)

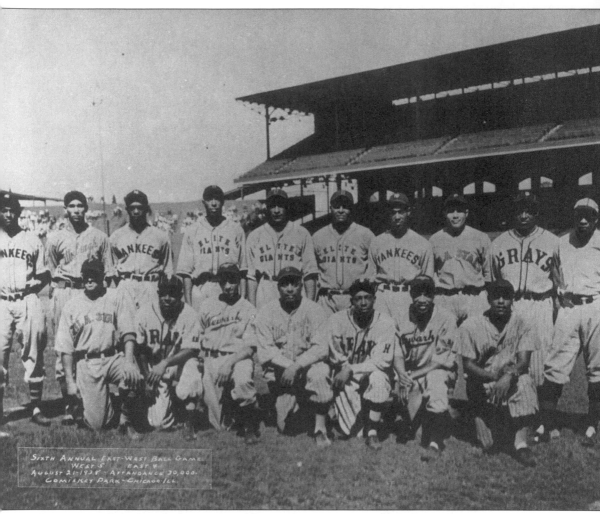

The 1938 East team, losers 5-4 in this year's contest, is pictured above, from left to right: (front row) Jake Dunn, Buck Leonard, Dickie Seay, Oscar Charleston, Vic Harris, Willie Wells, and Sam Bankhead; (back row) Rev Cannady, Johnny Taylor, Thad Christopher, Sammy T. Hughes, Bill Wright, Biz Mackey, Barney Brown, Henry McHenry, Edsall Walker, and Jim Brown. Hughes, Wells, and Bankhead each had two hits. (Courtesy of NoirTech Research Inc.)

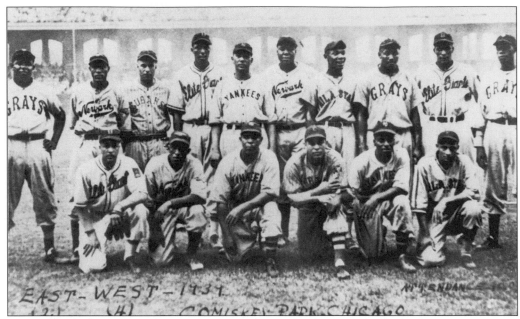

The 1939 East Squad is pictured from left to right: (front row) Bill Byrd, Leon Day, Bill Holland, Cando Lopez, Goose Curry, and Roy Parnell; (back row) Buck Leonard, Willie Wells, Jose Fernandez, Sammy T. Hughes, George Scales, Mule Suttles, Pat Patterson, Josh Gibson, Bill Wright, and Roy Partlow. The East Squad lost 4-2, as they were held to five hits by West pitchers Theolic Smith, Hilton Smith, and Double Duty Radcliffe. (Courtesy of NoirTech Research Inc.)

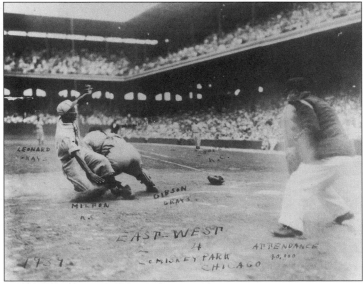

Action at the plate in the 1939 East-West All-Star game shows one of the greatest baseball players of all time Josh Gibson. Henry Milton of the Kansas City Monarchs is blocked off the plate and tagged out by Gibson of the Homestead Grays. Milton and the West team would go on to gain the victory over Gibson and the East team by a score of 4-2. (Courtesy of National Baseball Hall of Fame.)

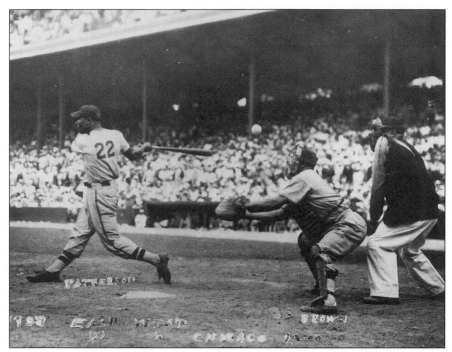

Number 22, Pat Patterson of the Philadelphia Stars, connects for a single to center field in front of 40,000 fans at Comiskey Park. A third baseman and member of the 1939 East team, Patterson went one for four in the game and scored a run. His East squad lost the game by a score of 4-2. (Courtesy of National Baseball Hall of Fame.)

West team members celebrate their victory at the 1939 East-West All-Star game at Comiskey Park. The victors are pictured, from left to right: Ted Strong of the Kansas City Monarchs, Parnell Woods of the Cleveland Buckeyes, Dan Wilson of the St. Louis Stars, and Neil Robinson of the Memphis Red Sox. Robinson went 3 for 4 in the game, scored one run and batted in one run. Wilson gained the "seat of honor" by hitting a home run to win the game. (Courtesy of National Baseball Hall of Fame.)

J.B. Martin in his traditional white suit (minus his white straw hat), surveys Comiskey Park to insure all-star festivities and accommodations are in place. Dr. Martin, former pharmacist, came to Chicago in October of 1940, after selling his interest in the Memphis Red Sox. The Meharry Medical College graduate later became president of the Negro American League and served until the league filed dissolution papers in 1960. (Courtesy of NoirTech Research Inc.)

This house at 4552 Michigan Avenue was once the home of Negro American League president Dr. John B. Martin. After going against Memphis political boss E. H. "Boss" Crump in a presidential election, Martin was forced to leave the Blues City and relocate to the Windy City. The former Memphis Red Sox owner became owner of the Chicago American Giants in the early forties. (Courtesy of Jerry Malloy.)

At 2400 South Michigan Avenue are the offices of the *Chicago Defender*, as they appear today. The *Defender* was one of the most influential African American newspapers in America and the biggest promoter of East-West All-Star classic. The *Defender* printed ballots that readers would clip, fill out, and mail in with their selections of players for the annual all-star event. (Courtesy of Jerry Malloy.)

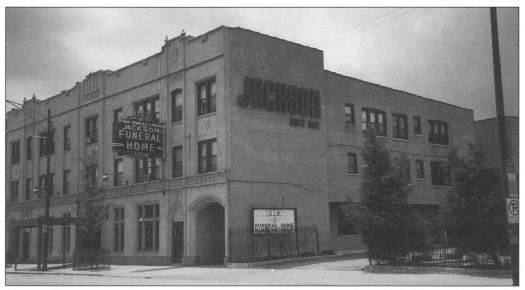

The Jackson Funeral Home at 3800 Michigan Avenue is a longtime Bronzeville landmark. The business was owned and operated by Charles E. Jackson and had a motto that included "consideration for the living, reverence for the dead". Jackson Funeral Home, like a number of businesses in black Chicago, placed ads in the programs sold at the annual East-West All-Star game. (Courtesy of Dick Clark.)

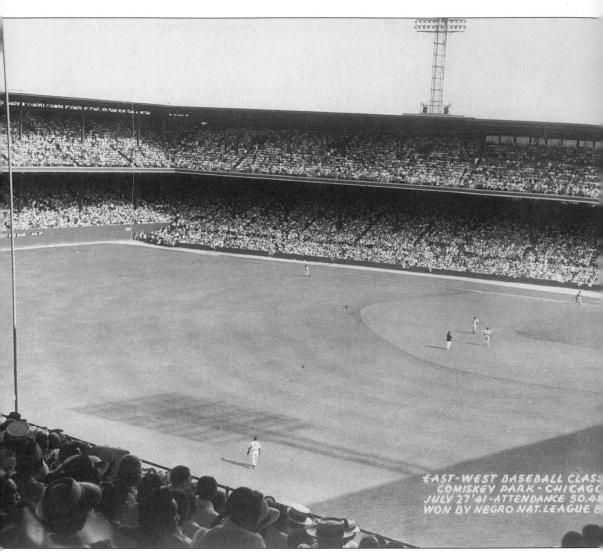

EAST-WEST BASEBALL CLASS
COMISKEY PARK - CHICAGO
JULY 27 '41 - ATTENDANCE 50,4
WON BY NEGRO NAT. LEAGUE 8

A record crowd of 50,485 fans were present at the 1941 East-West All-Star game. The game, played on July 27th, saw the East Squad win 8-3. Four future members of the Baseball Hall of Fame, Satchel Paige, Buck Leonard, Monte Irvin and Roy Campanella, played in the game. Paige played for the West team, and the others for the East team. (Courtesy of NoirTech Research Inc.)

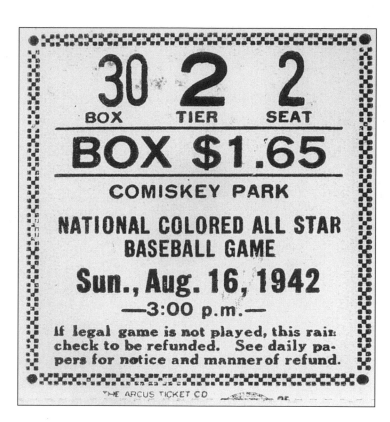

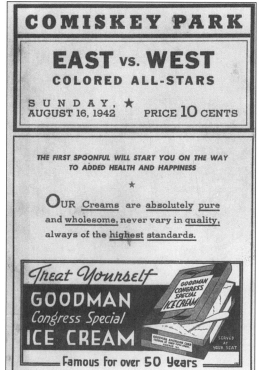

Here is your ticket to the 1942 National Colored All Star Baseball Game. The finest seat at Comiskey Park to witness black baseball's best athletes cost only a buck sixty-five. For another dime you could enjoy Goodman's Congress Special Ice Cream. A great price to see Buck, Josh, Judhead and Spider play. (Courtesy of NoirTech Research Inc.)

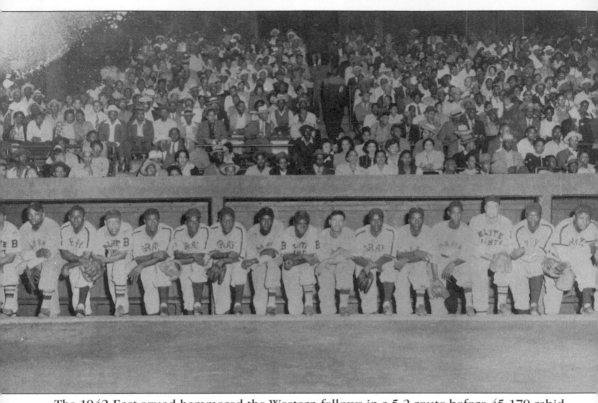

The 1942 East squad hammered the Western fellows in a 5-2 route before 45,179 rabid fans. The East squad is pictured above, from left to right: George Scales, Big Jim West, Buck Leonard, Felton Snow, Sam Bankhead, Johnny Wright, Jud Wilson, Henry Spearman, Henry Kimbro, Gene Benson, Jerry Benjamin, Pat Patterson, Barney Brown, Bill Byrd, Matt Carlisle, Josh Gibson, and Robert Clarke. (Courtesy of NoirTech Research Inc.)

The all time batting leader at the East-West All-Star games was Neil Robinson of the Memphis Red Sox. Appearing in nine games, Cornelius led all batters with a .500 average, beating out Josh Gibson's .459. In the 1939 classic, Robinson tallied an all-star record of seven total bases with a single, double, and home run. (Courtesy of the National Baseball Hall of Fame.)

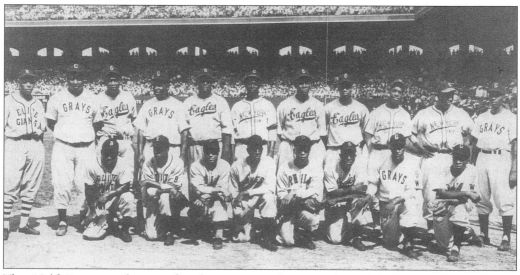

The 1946 East squad poses for the camera. They are, from left to right: (front row), Henry Kimbro, Jonas Gaines, Murray Watkins, Bill Ricks, Gene Benson, Leon Day, Sam Bankhead and Howard Easterling; (back row) Felton Snow, Josh Gibson, Monte Irvin, Buck Leonard, Biz Mackey, Pat Scantlebury, Len Pearson, Larry Doby, Fernando Pedroso, Silvio Garcia and Vic Harris. The East lost 4-1, as Gibson made his last all-star appearance, going oh-for-three. (Courtesy of NoirTech Research Inc.)

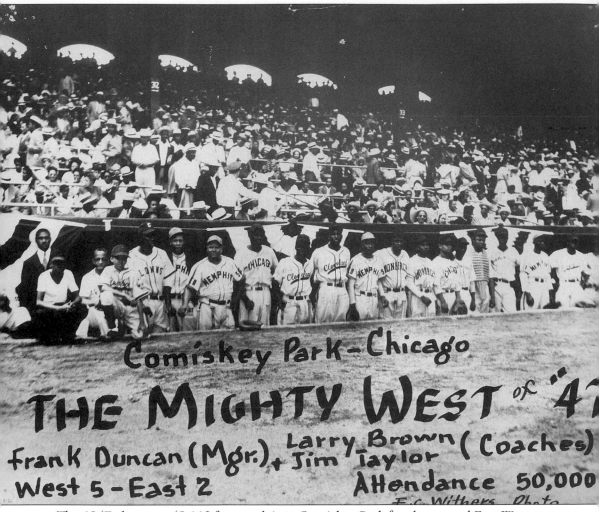

The 1947 class saw 48,112 fans pack into Comiskey Park for the annual East-West game. This West squad, behind Memphis Red Sox Dan Bankhead, won 5-2. The West team is, from left to right: (starting at fifth from left) Goose Tatum (Clowns uniform), Dan Bankhead, Larry Brown, Gentry Jessup, Leon Kellman, Chet Brewer, Verdell Mathis, Ford Smith, Herb Souell, John Ritchey, unidentified, Quincy Trouppe, Piper Davis, Jose Colas, Sam Jethroe, and Bob Abernathy. Jessup once pitched a one-hitter and hit a home run to defeat Booker T. McDaniel of the K.C. Monarchs, 1-0. (Courtesy of Ernest Withers.)

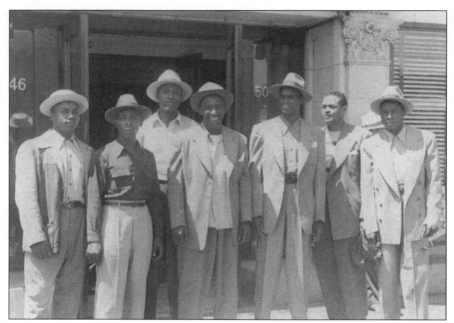

The host hotel for the annual all-star event was the Grand Hotel on 51st and South Parkway (now Martin L. King, Jr., Blvd.). Players selected for the 1947 game share a Kodak moment; they are, from left to right: Bob Abernathy (Indianapolis Clowns), Buddy Armour (American Giants), Chet Brewer (Cleveland Buckeyes), Jose Colas (Memphis Red Sox), Piper Davis (Birmingham Black Barons), Gene Smith (Cleveland Buckeyes), and Sam Jethroe (Cleveland Buckeyes).

Although at times he could be found playing in the outfield, Theolic Smith was best known as a pitcher by the nickname "Fireball." A member of the American Giants in 1948, 1949, and 1951, Smith was primarily a fast ball pitcher. Smith appeared in three East-West All-Star games during his career. In 1946, playing for the Mexico City Reds, Smith got into an argument with umpire Irvin Weimer. He knocked out Weimer with one punch. Smith was booked on assault charges, fined 1000 pesos and suspended for 15 days. (Courtesy of Maurine Smith.)

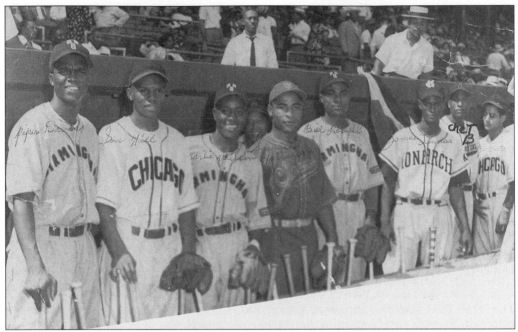

Appearing in the dugout at the East-West All-Star game of 1948 are, from left to right: Piper Davis (Birmingham Black Barons), Sam Hill (American Giants), Artie Wilson (Black Barons), Sam Hairston (Indianapolis Clowns), Bill Powell (Black Barons), Jim LaMarque (K.C. Monarchs), Chet Brewer (Cleveland Buckeyes), and Roberto Vargas (American Giants). (Courtesy of NoirTech Research Inc.)

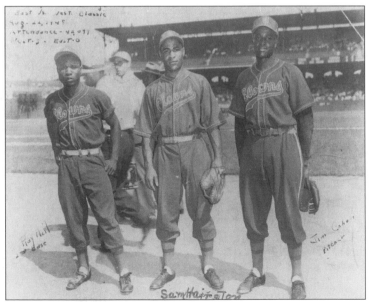

Although they never made it into the game, these Clowns were part of the West team in 1948 at Comiskey Park. The Indianapolis team members are, from left to right: third baseman Ray Neil, catcher Sam Hairston (future Chicago White Sox player), and pitcher Jim "Fireball" Cohen. The West team won the game 3-0. (Courtesy of Ray Neil.)

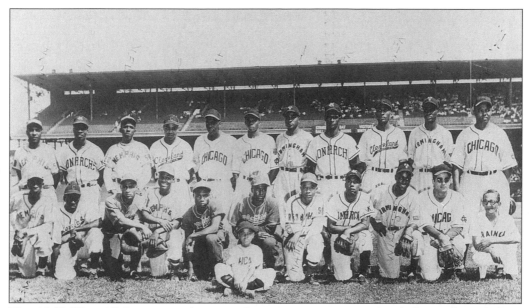

The 1948 West All-Star team shut out the East team 3-0. Pictured above, from left to right: (front row) Nat Rogers, Leon Kellman, Sam Hairston, Bob Boyd, Ray Neil, Jim Cohen, Verdell Mathis, Herb Souell, Artie Wilson, Roberto Vargas, and their trainer; (back row) Neil Robinson, Willard Brown, Spoon Carter, Willie Grace, Gentry Jessup, Sam Hill, Bill Powell, Jim LaMarque, Chet Brewer, Piper Davis, and Quincy Trouppe. Powell was the winning pitcher. (Courtesy of NoirTech Research Inc.)

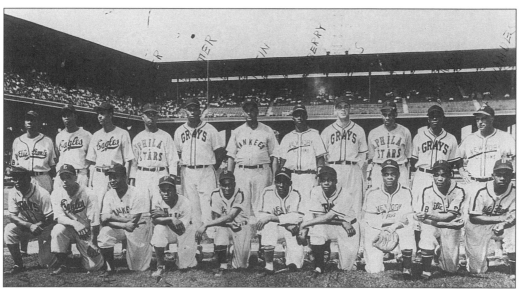

The 1948 East All-Star members are, from left to right: (front row) Buck Leonard, Bob Harvey, Marvin Barker, Frank Austin, Pee Wee Butts, Minnie Minoso, Luis Marquez, Louis Louden, Bob Romby, and Junior Gilliam; (back row) Lester Lockett, Monte Irvin, Rufus Lewis, Henry Miller, Luke Easter, Robert Griffith, Pat Scantlebury, Wilmer Fields, Bill Cash, Vic Harris, and Jose Fernandez. Minoso, Leonard, and Gilliam got the only hits in a losing effort to the West Squad. (Courtesy of National Baseball Hall of Fame.)

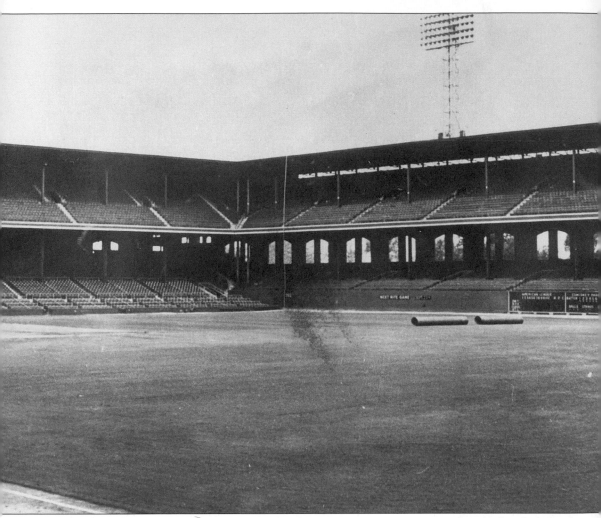

By 1951, the Chicago American Giants Opening Day game attracted only five hundred fans. By the end of the 1952 season the American Giants would be no more and Comiskey would sit empty and unused when the White Sox were on the road. The fall of the American Giants marked the first in over five decades that black baseball could not call Chi-Town home. (Courtesy of NoirTech Research Inc.)

Five

THE GREAT LAKES
NAVAL BASEBALL CLUB

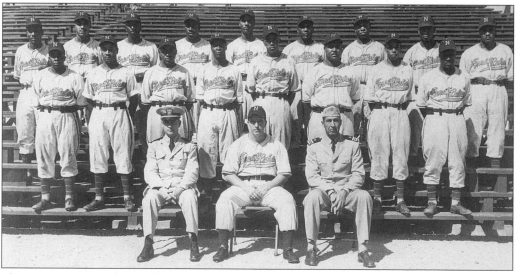

The Great Lakes Blue Jackets were an all-black team that was stationed at the Great Lakes Naval Station north of Chicago during World War II. The players are, from left to right: (from row) Lt. Luke Walton, Ensign Elmer Pesser, and Lt. Commander Paul Hinkle; (middle row) Earl Richardson, Howard Gay, Stephen Summerow, Luis Pillot, Unidentified, Leroy Clayton, Jeff Shelton, and Wyatt Turner; (back row) William Randall, Charles Harmon, John Wright, Andy Watts, Herb Bracken, Isaiah White, James Brown, Larry Doby, and William Campbell. Doby would go on to be the first African American to play in the American League, joining the Cleveland Indians in 1947. Harmon would become the first African American to play for the Cincinnati Reds in 1954 and the second black to play for the Philadelphia Phillies in 1957. (Courtesy of Jerry Malloy.)

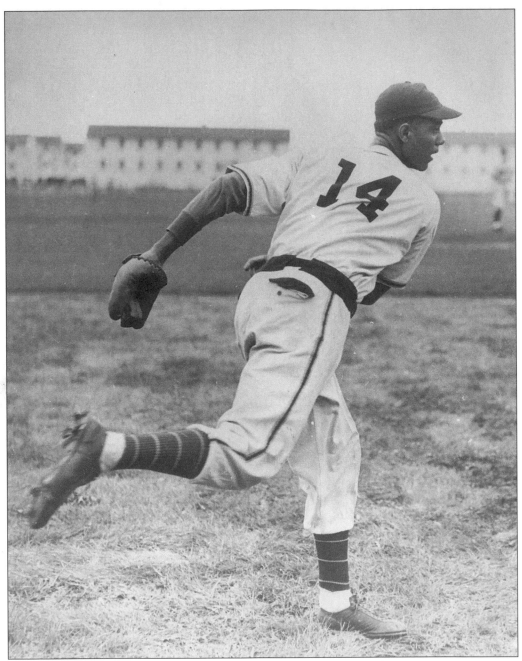

With a stealth fast ball, a roundhouse curve, and good control, Herb "Doc" Bracken beat every Negro American League team he pitched against as a St. Louis Star his rookie year of 1940. Bracken didn't play professionally in 1942 or 1943, but was still in top form when he joined the Navy in 1944. He became a member of the Great Lakes Naval Base's black team where he pitched in 1944 and 1945. (Courtesy of Jerry Malloy.)

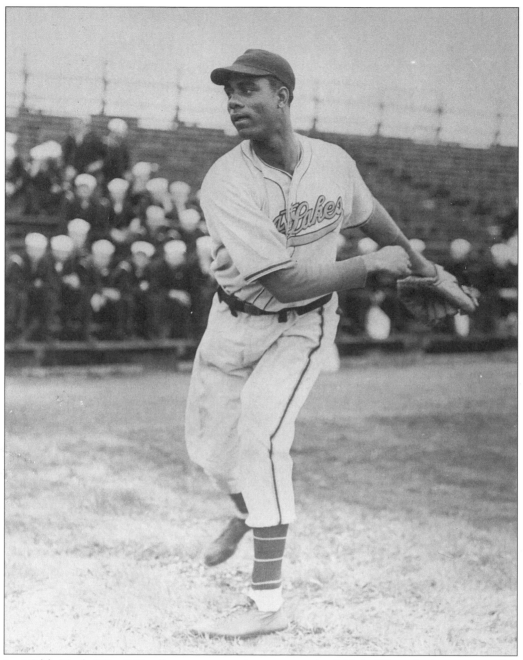

In 1944, Herb "Doc" Bracken put together a record of 13-1. His only loss was a 14-inning affair against future Hall of Fame catcher Mickey Cochrane's All-Star team. In that game Bracken gave up only one run and two hits. (Courtesy of Jerry Malloy.)

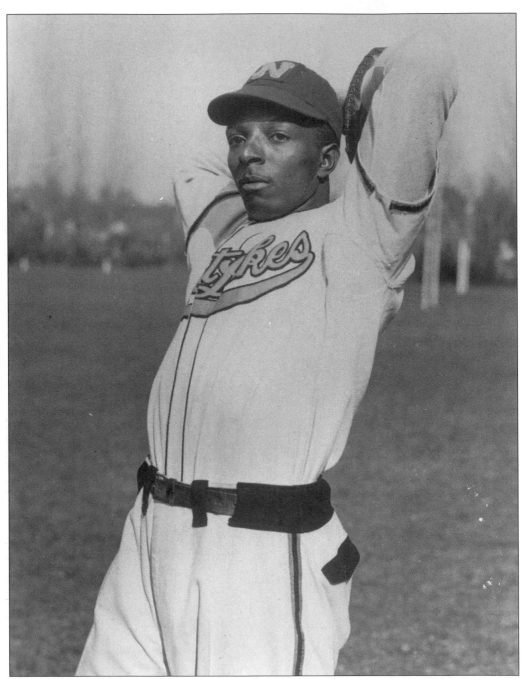

The second black player signed by the Brooklyn Dodgers was pitcher Johnny Wright, who played for the Great Lakes Blue Jackets. A great fast ball and an overpowering curve made Wright an effective cog of any machine. After the war, Wright was signed by Branch Rickey in 1946, but could not take the racial pressures of the time and returned to the Negro Leagues. (Courtesy of Jerry Malloy.)

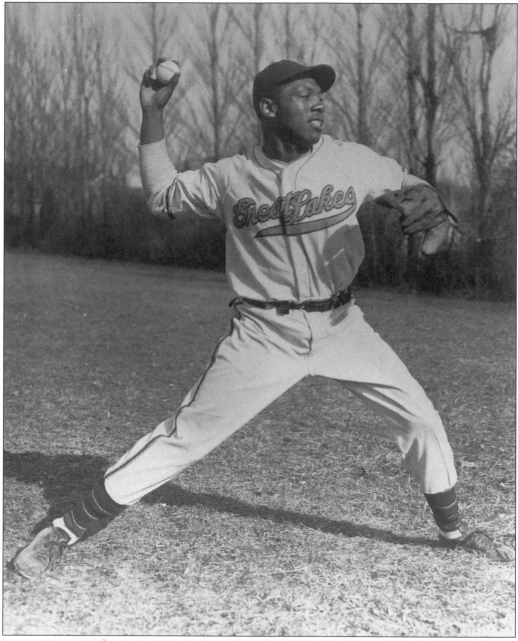

James Brown was a talented pitcher who played for the Newark Eagles before being drafted and joining the Great Lakes Naval Station Blue Jackets in 1944. Brown had a good fast ball and curve, and was also a talented outfielder. Unlike most pitchers he excelled with the bat, hitting .304 for Newark in 1941. (Courtesy of Jerry Malloy.)

Pictured here, from left to right: Sonny Randall, Leroy Coates, and Isaiah White were members of the all black version of the Great Lakes Naval Base baseball team during the second World War. At that time, most aspects of the military were segregated, including sports. Black soldiers were assigned to the Robert Smalls Division, named after the African American Civil War seaman. (Courtesy of Jerry Malloy.)

Six

MAJOR LEAGUE GIANTS

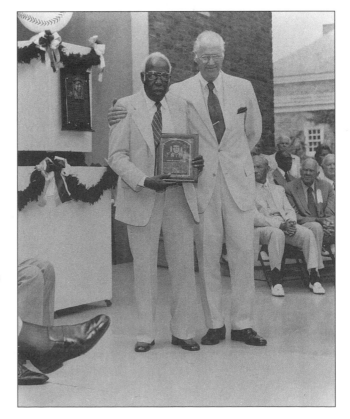

Earl Foster (left), with Baseball Commissioner Bowie Kuhn, accepts his father's Hall of Fame plaque in 1981. Rube Foster was the first Negro League veteran to be elected by the Hall of Fame's Committee on Baseball Veterans after the disbandment of the special Negro Leagues Committee. Although he was one of the premier pitchers of the Negro Leagues in the early part of the 1900s, Foster was inducted as a baseball executive for the founding and operation of the first black league to survive a full season. (Courtesy of National Baseball Hall of Fame.)

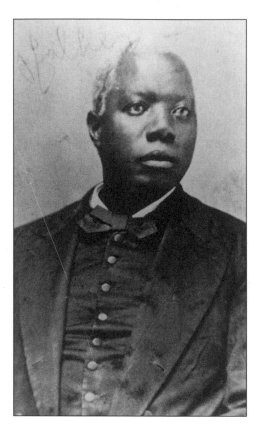

The fifth child of Reverend Andrew and Evaline Foster was the impeccable Andrew "Rube" Foster. Young Rube was born on September 17, 1879, in Calvert, Texas. His father, Rev. Foster, served as presiding elder for the United Methodist Churches around central Texas. (Courtesy of Doris Foster.)

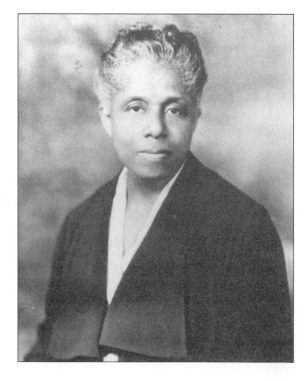

The woman referred to by historians as the "Mother of the Negro Leagues" is Sarah Foster, the wife of Rube Foster. While Rube was taking care of the operation of the League, Sarah could be found taking care of the players. There are numerous stories of Mrs. Foster extending her hospitality to players from the American Giants and visiting clubs. (Courtesy of Doris Foster.)

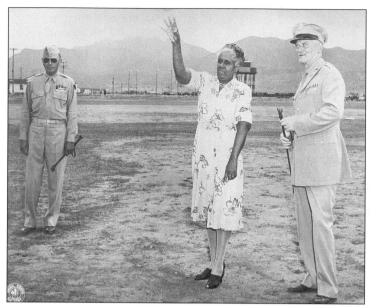

Mrs. Rube (Sarah) Foster throws out the first pitch at Rube Foster Memorial Field. Post commander Col. Edwin N. Hardy (far right) felt that naming the field after Foster would be an inspiration to the African Americans stationed there. Foster Field stands today at Fort Huachuca, Arizona, although it has been scaled down over the years to make room for new construction. (Courtesy of David Skinner.)

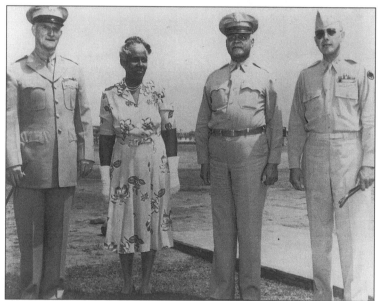

This picture was taken at the dedication of Rube Foster Memorial Field on July 18, 1943, at Fort Huachuca, Arizona, where 15,000 African American servicemen were stationed. Pictured above, from left to right were post commander Col. Edwin N. Hardy, who named the field, Mrs. Rube (Sarah) Foster, Brigadier General Benjamin O. Davis, and Major General Almond, commanding general of the 92nd Infantry Division. (Courtesy of Sammy J. Miller.)

Foster Field as it appears today is pictured here. Sarah Foster spoke at the dedication of Rube Foster Memorial Field. She said, "I learned that for a woman married to a public figure there are a lot of things to consider. The most important thing to consider is that your husband just doesn't belong to you. I tried to remember that, and I didn't try to get into everything he was in." (Courtesy of David Skinner.)

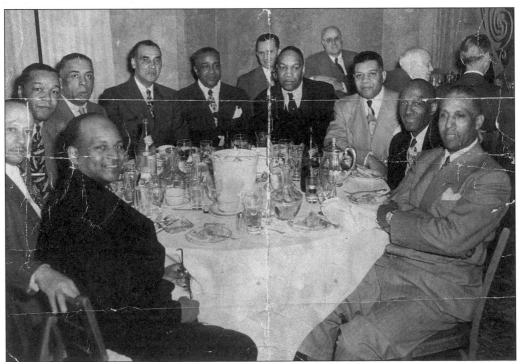

A banquet meeting of the Old Tyme Ball Players Club of Chicago. The former players are, from left to right: Ernie Carroll, Hanna Ball, Jack Marshall, Jim Bray, Joe Green, Jelly Gardner, Bingo DeMoss, Charles Johnson, Dave Malarcher, and John Donaldson. With the exception of Carroll and Ball, all the men played for Chicago-based teams. (Courtesy of Charles Johnson.)

Future Chicago White Sox Connie Johnson (right) with catcher Fermin "Mike" Guerra in Cuba, was with St. Hyacinthe of the Canadian Provincial League in 1951. That season Johnson went 15 and 14 and led the league with 172 strikeouts. The following year with the Colorado Springs of the Western league, Johnson had a win-loss record of 18-9, with 233 strikeouts. (Courtesy of Connie Johnson.)

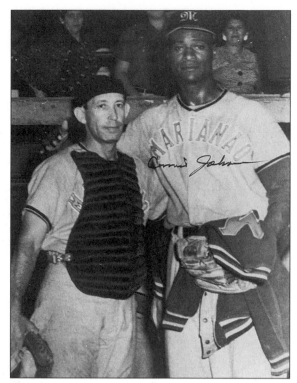

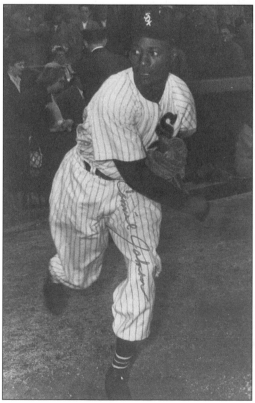

Negro League legend Clifford "Connie" Johnson takes some warm ups while with the Chicago White Sox. In the forties, Connie Johnson was part of the Kansas City Monarchs' powerful pitching staff that included the likes of Satchel Paige and Hilton Smith. After spending 1951 in the minors, Johnson was signed by the White Sox organization. In 1953 Connie made it to the bigs, appearing in 14 games, with a record of four and four, with a 3.56 ERA and 44 strikeouts. Johnson spent 1954 in the minors and was back with the White Sox in 1955 with a record of seven and four in 17 games, posting 72 strikeouts and an ERA of 3.45. Johnson appeared in five games with the ChiSox in 1957 before being traded to the Baltimore Orioles. (Courtesy of Connie Johnson.)

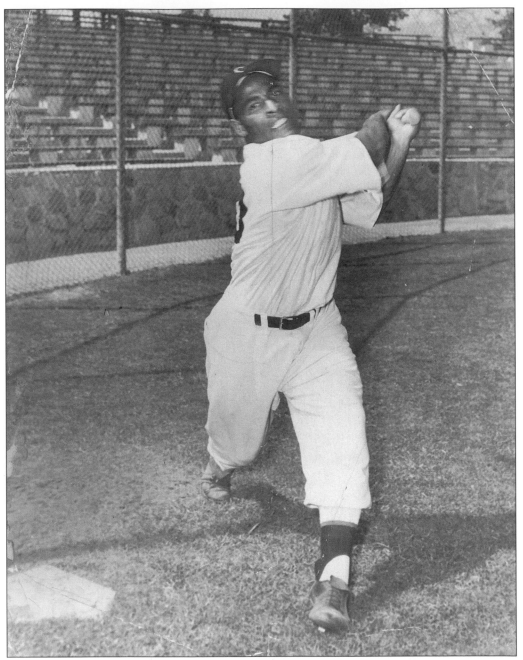

During his time with the Chicago White Sox farm system, Sam Hairston was one of the hardest men in the game to strike out. In 1953, he hit .310 and struck out 19 times in 535 plate appearances. In 1955, at the age of 35, Hairston had 546 at bats, hit .350 and struck out only 30 times. (Courtesy of NoirTech Research Inc.)

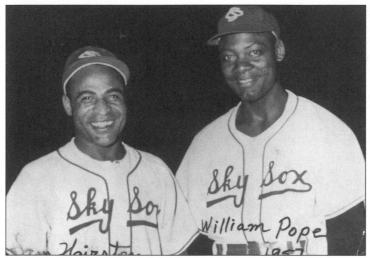

Although he would only play four games in the majors with the Chicago White Sox, catcher Sam Hairston secured his place in history when he won the Negro American League Triple Crown in 1950 with a .424 batting average, 17 home runs, and 71 RBI's in 70 games. In 1952 Hairston, with the Colorado Springs Sky Sox of the Western League, won the leagues Most Valuable Player award. He and pitcher Willie Pope (on the right) were the first black battery in the Western League. (Courtesy of NoirTech Research Inc.)

While Minnie Minoso was the first black player to appear on the field for the Chicago White Sox, catcher Sam Hairston was the first African American signed by the team. Hairston began his career in the Negro Leagues playing for the Birmingham Black Barons and Cincinnati-Indianapolis Clowns before signing with the White Sox in 1950. The catcher made it to the major leagues in 1951, where he appeared in four games. In those games, Hairston came to the plate fives times, getting two hits with one double, one RBI, and a run scored. He spent the next nine years playing in the minor leagues. Hairston, while working as a scout for the White Sox, signed his son, Jerry Hairston, to a contract. Sam is the first black major leaguer to have a son play in the majors. (Courtesy of Sam Hairston.)

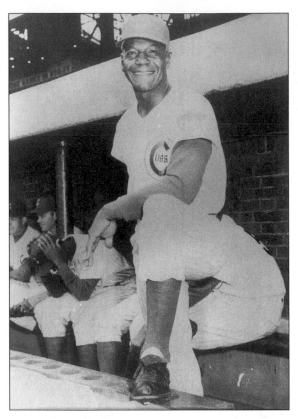

The first black coach in the major leagues was John "Buck" O'Neil of the Chicago Cubs. Signed by the Cubs as a scout in 1956, O'Neil, who managed the famed Kansas City Monarchs from 1948 to 1955, made major league history in 1962 when he donned his coach's uniform. O'Neil is currently a member of the National Baseball Hall of Fame's Veterans Committee. (Courtesy of Buck O'Neil.)

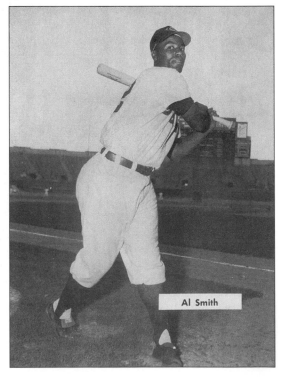

Outfielder Al Smith played in the Negro Leagues from 1946-1948 before joining organized baseball in 1949. He finally made it to the majors with the Cleveland Indians in 1953 and was traded to the Chicago White Sox, where he played from 1958-1962. Smith's best years with the White Sox were 1960, when he hit .315 with 12 home runs, and 1961 when he hit .278 with 28 home runs. (Courtesy of Dick Clark.)

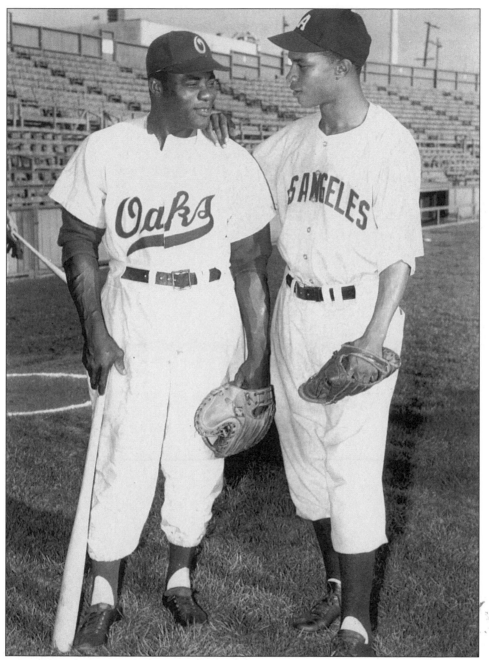

Former Negro League shortstop with the Kansas City Monarchs from 1948 to 1950, Gene Baker (on the right, with New York Cubans catcher Ray Noble) was signed by the Chicago Cubs in 1950. After spending 1950-1953 in the team's farm system with Des Moines of the Western League, and later with Los Angeles of the Pacific Coast League, Baker reached the Cubs in late 1953. As a Cub, Baker appeared in 448 games, all at second and compiled a lifetime batting average of .256. (Courtesy of NoirTech Research Inc.)

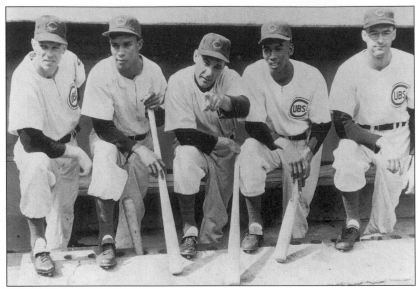

After switching to second base in 1953, Baker joined Ernie Banks to form the first black "keystone combination" in major league history. Pictured here on September 14, 1953, Manager Phil Cavaretta (center) gives instructions to outfielder Bob Talbot (far left), Baker, Banks, and Bill Moisan (far right). Baker played with the Cubs until partially into the 1957 season when he was traded to the Pittsburgh Pirates. Banks remained with the Cubs throughout his career. (Courtesy of NoirTech Research Inc.)

Ernie Banks, discovered by Cool Papa Bell, began his professional career in 1950 as a shortstop for the Kansas City Monarchs. He is shown here in 1963, with his three-year-old twins, Joel (front) and Jerome, participating in a little horseplay. After spending 1951-1952 in the military, Banks returned to the Monarchs in 1953 and hit .347. Later that year Banks was signed by the Chicago Cubs and went on to become the first player from a losing team to win the Most Valuable Player award (1958). (Courtesy of National Baseball Hall of Fame.)

In this photo, Cuban Orestes "Minnie" Minoso sports his new caddy. Minoso played for the New York Cubans of the Negro National League. He became the first black player with the Chicago White Sox in 1951. Minoso remained with the White Sox through the end of the 1957 season before being traded. During this period he led the American league in stolen bases for three consecutive seasons (1951, 1952, & 1953), in triples three times (1951, 1954, & 1956) and in doubles once (1957). "Minnie" returned to the White Sox in 1960, when he led the league in hits, through 1961 and again in 1964. A White Sox legend, Minoso appeared in 1374 games and had an average of .297. (Courtesy of Connie Johnson.)

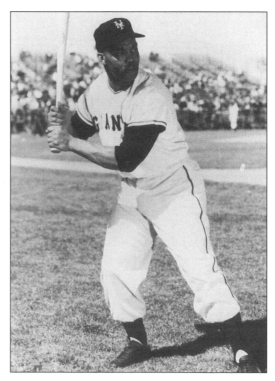

A member of the World Championship Newark Eagles in 1946, Monte Irvin joined the New York Giants in 1949 as their second black player. In 1956, at the age of 37, Irvin became a Chicago Cub. He played in 111 games, had a .271 batting average, hit 15 home runs, and had a .991 fielding percentage. (Courtesy of Dick Clark.)

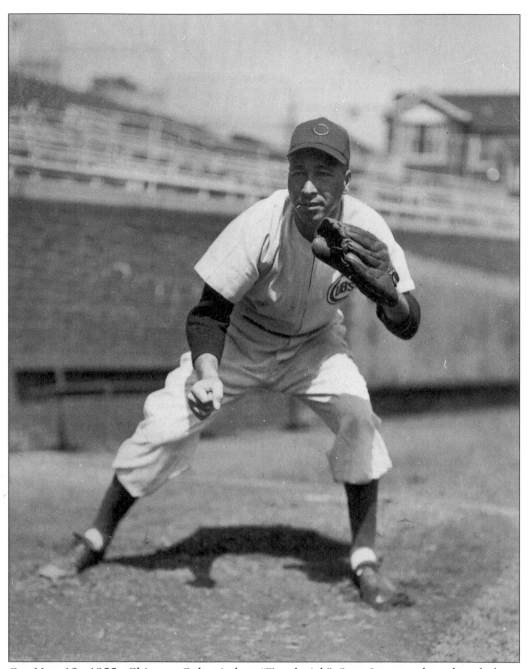

On May 12, 1955, Chicago Cub pitcher "Toothpick" Sam Jones, who played three seasons in the Negro leagues, became the first African American to pitch a no hitter in the major leagues. Jones threw 136 pitches and used one toothpick to no hit the Pittsburgh Pirates at Wrigley Field. Jones was awarded a gold toothpick for this hitless feat. (Courtesy of National Baseball Hall of Fame.)

Seven
THE RECOGNITION YEARS

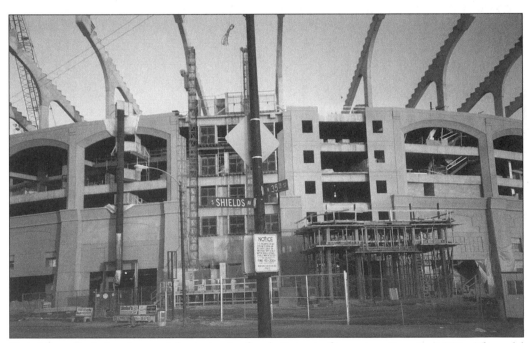

Comiskey Park is pictured here in its final stages of construction in 1991. The old Comiskey held many memories of black baseball. Besides hosting the annual all-star game, on July 5, 1947, the color barrier was broken by Larry Doby of the Cleveland Indians as he marched to the plate to pinch-hit. Later on May 1, 1951, Minnie Minoso became the first black player for the team. In his first plate appearance, Minoso hit a home run off of Vic Raschi of the Yankees. Minoso (in 1960) and Elston Howard (1961) are the only former Negro Leaguers credited with hitting rooftop shots. (Courtesy of NoirTech Research Inc.)

The new Comiskey Park will never host a Negro League game, but it was one of the first parks in the country to honor the heritage of former Negro League players in 1992. The new park has a capacity of 44,321 with eight-foot high fences. Unlike the old Comiskey, the new columnless design results in an unobstructed view for fans. However, like the old Comiskey, it is still a pitchers' park. (Courtesy of National Baseball Hall of Fame.)

Founder of the *Chicago Defender* was Georgian, Robert S. Abbott. Abbott used his paper to urge Southern blacks to move North. In 1917, Abbott printed an ad that read in part, "The *Defender* invites all to come North. Plenty of room for good, sober, industrious men. Plenty of work." The ad went on to state that "anywhere in God's country is far better than the South land." (Courtesy of the *Chicago Defender*.)

Former Negro leaguers and current Chicago residents, Lester Lockett (left), and Ted "Double Duty" Radcliffe (right), are pictured with 19th Century baseball historian Jerry Malloy. In 1986 Malloy, while celebrating his 40th birthday, appeared with Lockett and Duty on WBEZ radio station to spin some yarns. The pitching and catching Radcliffe and Lockett, infielder and outfielder, played together on the Chicago American Giants in 1942 and 1950 and were together as members of the Birmingham Black Barons from 1942–1946. (Courtesy of Brandon Malloy.)

In 1992 the Chicago White Sox became one of the first major league teams to host a Negro League reunion and recognition. Joining in the festivities were former New York Cuban third baseman Minnie Minoso (left), an outfielder for the White Sox, and former Kansas City Monarchs shortstop Ernie Banks (right) who played for the Cubs. Thumbs up to a great event and the White Sox organization. (Courtesy of Debra Meeks.)

Other attendees at the celebration included Buck O'Neil, the first black coach in the majors with the Cubs in 1962, Dewitt "Woody" Smallwood, former outfielder with the New York Black Yankees, and the newly-acquired sensational Bo Jackson, a strong supporter of Negro League players. (Courtesy of Debra Meeks.)

An all-star team of talent poses in front of the new Comiskey Park in 1992 after the game. They are, from left to right: John "Mule" Miles, Sam "Jet" Jethroe, Joe Black, Connie Johnson (rear), Col. Jimmie Crutchfield (front), Clint "Butch" McCord, Ted "Double Duty" Radcliffe (front), Lester Lockett, Minnie Minoso, Sam Jethroe III, Clyde "Junior" McNeal, Claro Duany (front), Gene Baker, Gene Benson, Perry Hall (front), Albert "Buster" Haywood, John "Buck" O'Neil and Frank Duncan III. "Everybody, regardless of who you are, wants to be recognized for something," said Crutchfield. "Although it's a little late, it's better later than never," he added. (Courtesy of Timothy Bohus.)

John "Buck" O'Neil at his best at the 1992 celebration, preaching about the glory days of the black leagues. Standing to O'Neil's right is master of ceremonies Warner Saunders. In his rousing speech to the sold out Comiskey crowd, Buck expressed, "There shouldn't have been a black league. This is America - everyone should play. This (tribute) means everything to me." Buck added, "I've been trying for 60 years for something like this." (Courtesy of NoirTech Research Inc.)

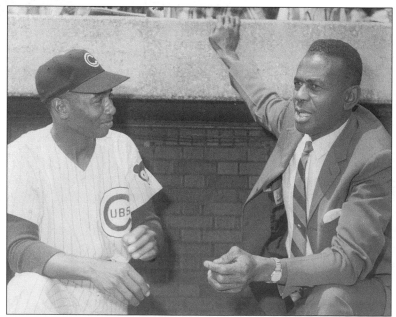

Former Kansas City Monarch Ernie Banks listens to the wise and prophetic Satchel Paige. In 1948 Paige, for the St. Louis Browns, became the first black pitcher to throw a nine-inning shutout in the American League. Ageless at 42, Paige shut out the Chicago White Sox 5-0 before a sellout crowd of 51,013 at Comiskey Park. (Courtesy of George Brace.)

John "Mule" Miles, who played all outfield positions with the Chicago American Giants, was better known in his hometown of San Antonio, Texas. A local semi-pro baseball and basketball hero, Miles was encouraged to try out with the American Giants by fellow Texas resident Clyde McNeal. Today, the hard playing Mule is a soft-hearted deacon at a Texas church. (Courtesy of Lisa Feder.)

This Chicago native and former American Giant is Big Jim McCurine. He claims his biggest thrill in baseball was hitting a triple to break up a tie 23-inning game against the Indianapolis Clowns in 1946 and hitting a grand slam off of Jay Heard. McCurine recalls the Monarchs pitching staff of Lefty LaMarque, Hilton Smith, Gene Collins and Satchel Paige as the toughest pitchers he ever faced. Who was the best hitter he ever saw? That's easy—Josh Gibson! (Courtesy of Lisa Feder.)

121

Napoleon Gulley eyeballs a potential prospect. After his days in the Negro Leagues, the dapper and talkative Nap signed with the Brooklyn Dodgers in 1950. He switched from pitching to outfielding to play with Visalia in the California League. He retired from active play in 1956 after two seasons with Spokane of the Northwest League. Upon leaving the diamond, he opened a graphic arts business in Chicago. (Courtesy of Lisa Feder.)

Eight
THE LAST AT BAT

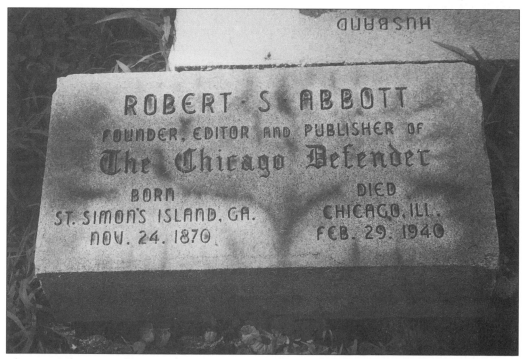

The recently erected gravestone of Robert S. Abbott, founder of the *Chicago Defender*, is pictured above. One of the nation's most important black weekly newspapers, it played a major role in the migration of African Americans from the South into Chicago before World War II. (Courtesy of Jerry Malloy.)

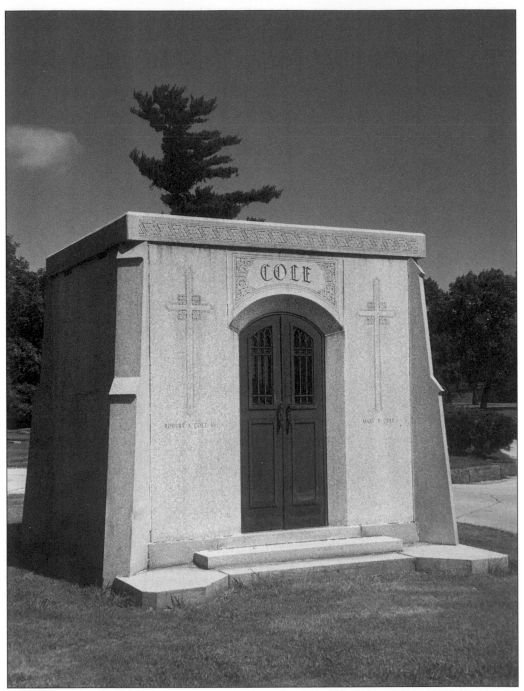

This is Robert Alexander Cole's monument as it stands today in Lincoln Cemetery. Known as "King Cole," he was one of Chicago's most successful businessman. He was president of the Metropolitan Funeral System Association from 1927 to 1956. In early 1932, Cole purchased the American Giants from white florist William E. Trimble. In 1935 he sold the club to fellow mortician Horace G. Hall, who held the franchise until Dr. J.B. Martin and William Little took control in 1941. (Courtesy of Jerry Malloy.)

Pictured above is the gravestone of Beauregard Fitzhugh Moseley in Lincoln Cemetery at 123rd and Kedzie. Moseley helped finance the Leland Giants in 1907, serving as their Secretary-Treasurer. He sided with Rube Foster in their successful takeover of the Leland Giant name in 1910. The Georgia native was a lawyer, coming to Chicago in 1896 and admitted to the Illinois bar that year. Moseley was also chairman of the colored committee of the Republican Party supporting the candidacy of Medill McCormack for the U.S. Senator and gave speeches on the behalf of William McKinley and Teddy Roosevelt. Moseley died at the Fort Dearborn hospital of influenza in 1919, with family members, famed councilman Oscar DePriest, and Senator McCormack at his bedside. (Courtesy of Jerry Malloy.)

On December 9, 1930, Andrew "Rube" Foster, age 51, died at the Institution of Rehabilitation at Kankakee, Illinois. Thousands of Chicago area residents viewed Foster's body, and three thousand mourners were present for the funeral. The white chrysanthemum baseball sent by the NNL directors and officers weighed 200 pounds, while the American Giants Booster Association sent the floral baseball diamond bearing Foster's initials. The floral arrangement bearing "Our Heart" was from his immediate family. Future owner and florist W.E. Trimble sent a large floral piece of white and yellow roses that covered the coffin. (Courtesy of Doris Foster.)

The final resting place of Andrew "Rube" Foster is pictured here as it appears today in Chicago's Lincoln Cemetery at 123rd and Kedzie Avenue. Roughly three thousand worshipers attended Foster's funeral at St. Mark's African Methodist Episcopal Church on 50th and Wabash Avenue. The *Chicago Defender* stated, ". . . he died a martyr to the game, the most commanding figure baseball has ever known." (Courtesy of Jerry Malloy.)

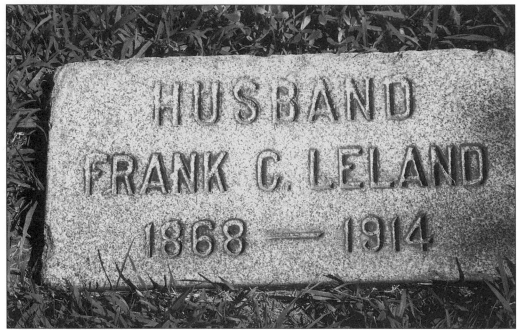

If Frank Leland had not hired Rube Foster to manage his Leland Giants, it is doubtful that Chicago would have been home to the great Foster teams or the Negro National League. This simple flat stone is not indicative of the greatness of Leland's pioneering efforts in giving black baseball a permanent presence in the Midwest. (Courtesy of Jerry Malloy.)

This 6 by 8 foot Negro League high-relief marker was dedicated at Sandcastle Stadium in Atlantic City, New Jersey on August 20, 1999. Artist Jennifer Frudakis said, "[t]he composition of this relief is designed to first draw the viewer in with a powerful central figure, Andrew (Rube) Foster, Father of Negro League Baseball." The sculpture demonstrates that Foster's Chicago-based league has had a national influence. (Courtesy of Dick Clark.)